MW01145243

GOLDEN HURRICANE
BASKETBALL
at *The University of Tulsa*

GOLDEN HURRICANE
BASKETBALL
at The University of Tulsa

Chad Bonham

ARCADIA

Copyright © 2004 by Chad Bonham
ISBN 0-7385-3346-7

Published by Arcadia Publishing
Charleston SC, Chicago, IL, Portsmouth NH, San Francisco, CA

Printed in Great Britain

Library of Congress Catalog Card Number: 2004111613

For all general information contact Arcadia Publishing at:
Telephone 843-853-2070
Fax 843-853-0044
E-mail sales@arcadiapublishing.com
For customer service and orders:
Toll-Free 1-888-313-2665

Visit us on the internet at http://www.arcadiapublishing.com

CONTENTS

ACKNOWLEDGMENTS

I want to thank all of the great people at The University of Tulsa who were tremendously helpful as I put this project together. They include Don Tomkalski, Judy MacLeod, Jason West, Stephanie Hall and Roger Dunaway. Don gave me the opportunity to work in the Sports Information Department as a freshman and his help with last-minute research and details was invaluable. I would also like to thank Wayne McCombs whose work *Baseball in Tulsa* inspired me to write historical pieces on Golden Hurricane football and basketball.

I'm equally thankful for all of the hard work put into this by everyone at Arcadia. In particular, thanks to John Pearson, Jeff Ruetsche, Stephanie Keller and anyone else that played a part in this effort behind the scenes.

Throughout this book, you will read quotes from a handful of individuals that were instrumental in the success of TU basketball. I appreciate the time they gave to me and the permission to include them in the text. That list includes former players Gary Collier, Jim King, Rod Thompson and Alvin Williamson; former head coaches Ken Hayes, Steve Robinson, and Bill Self; former assistant coaches Scott Edgar and Andy Stoglin; current coach John Phillips, and members of the media Bruce Howard, Ken MacLeod and Jimmie Tramel. Special thanks to Jimmie who also provided some great research material on the 1993–94 and 1996–97 seasons.

As always, I'm eternally grateful to my wife Amy Bonham who endured the late hours that were usually caused by my poor time management skills. And to my baby boy Lance, all I can say is thanks for being too young to notice that I spent more time behind my computer than playing with you. One of these days, I'll take you to some TU basketball games to make up for it.

Finally, my faith in Christ is the most important thing in my life no matter what topic I choose to write about. Therefore, I can't fail to recognize my Heavenly Father for continually blessing me with such wonderful opportunities. I couldn't have written a single word of this book without the talent and ability that God has given me. Above all of the rest, I give thanks to Him.

INTRODUCTION

It's been 25 years since a young coach named Nolan Richardson entertained his way into the hearts of Tulsa sports fans. They were overtaken by his confident swagger and mystified by his teams' tenacity and explosiveness. Perhaps the people were hypnotized by the trademark polka dots he routinely wore. Maybe he was really just that good. Judging by the smash hit he would later produce at the University of Arkansas, it's probably the latter.

But as much as Richardson meant to The University of Tulsa, it's important to note that many great men laid the foundation before him and another generation of coaches and athletes proudly carried the torch after his departure. In other words, the tradition that is TU basketball transcends any one era and cuts through decades of excellence. That's what this book is all about. It's a celebration of all of the outstanding individuals and great teams that have been a part of Golden Hurricane basketball.

For some fans, the fond memories might go all the way back to the old Fairground Pavilion where the games were seen through a smoke-filled haze and birds routinely flew across the building and left special "gifts" on the court. Basketball legends like Oscar Robertson and John Wooden graced that floor, but so did TU greats like Bob Patterson, Jim King, Bobby Smith, Steve Bracey and Willie Biles. From 1949 through 1975, coaches Clarence Iba, Joe Swank and Ken Hayes deserve a great deal of credit in establishing the tradition enjoyed today.

For others, the TU experience begins at the Maxwell Convention Center in downtown Tulsa. It was the arena that housed Richardson's legendary teams of the early 1980s. Paul Pressey, Bruce Vanley, Ricky Ross, Steve Harris and Herb Johnson were just a few of the players that became household names throughout the city thanks to the 1981 NIT Championship. Tubby Smith also took Tulsa to new heights in that building with help from Gary Collier, Lou Dawkins, Alvin "Pooh" Williamson and Shea Seals. Tulsa's repeat Sweet 16 appearances in 1994 and 1995 have yet to be matched.

There are many followers that have just recently joined the growing contingency of Hurricane supporters. For those newcomers to the family, images of Bill Self performing a song and dance along the sidelines of the Reynolds Center come to mind as TU flirted with national glory in the year 2000. Cast members Eric Coley, Tony Heard, Brandon Kurtz and David Shelton were among the key players featured on that Elite Eight stage. A year later, Buzz Peterson emerged from behind the curtains only to perform a disappearing act. But first he pulled an NIT title out of his hat with help from his lovely assistants Greg Harrington, Marcus

Hill, Dante Swanson and Kevin Johnson.

The following pages are just a small sampling of what TU basketball has meant to the city of Tulsa. There is no way to convey the entire story in the pages that follow. Hopefully the words and images will capture your imagination and take you back to all of the great moments we've enjoyed together.

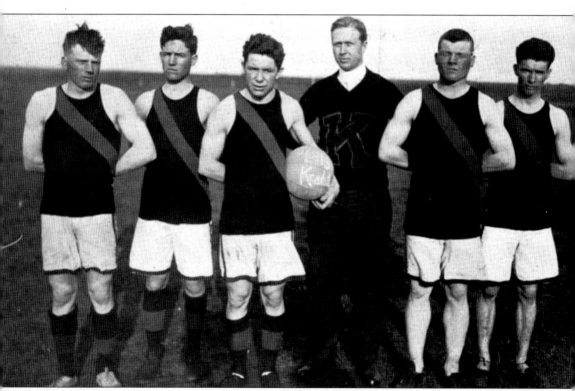

Pictured is the 1913–14 Kendall College team. Standing, from left to right, are Paul Handley, Wyatt Miller, Galord Simons, Head Coach Harvey Allen, Ralph Handley and Tom Roy. (Courtesy of The University of Tulsa.)

ONE
Trail Blazers
1907–1949

In the early 1900s, basketball was a relative newcomer to the American sports landscape. Historians report that Dr. James Naismith first concocted the idea of shooting a ball into a basket at the top of a tall pole in 1891. Football was already growing in popularity, having been invented 12 years earlier, and its round ball counterpart had some catching up to do. Early on, it was the Ivy League schools that dominated basketball. Yale was considered by many to be the best team in the country during the 1900–01 and 1902–03 seasons. Minnesota's undefeated 11-0 season set the standard in 1901–02. Columbia and Dartmouth represented the best of the best from 1903 to 1906 before Chicago came along to record a combined 55-4 mark under Coach Joseph Raycroft between 1906 and 1909.

It was during Chicago's dominance that The University of Tulsa's basketball program was birthed. In 1907–08, W.R. Bergen pioneered the fledgling hoops team at the same time as Kendall College was moving from Muskogee to Tulsa. The school's first football team was fielded 10 years earlier. The Kendallites only played two games that season, splitting a pair with Oklahoma State (known as Oklahoma A&M until the late 1950s). In 1908–09, Bergen led the team to a 3-1 record with another split against Oklahoma State and victories against Claremore Prep and Sapulpa Prep.

After a four-year sabbatical, Harvey Allen resurrected the team in 1913–14 and directed his five-man squad to a 3-2 record. He had spent the previous year as the head football coach. His basketball squad was led by a pair of brothers named Paul and Ralph Handley. The following season, Kendall College, Oklahoma and Oklahoma State joined to form the Oklahoma Collegiate Conference. Under the direction of first-year head coach Forest Rees, the team recorded a 6-3 mark, including a 4-0 sweep of the Aggies.

In 1915, a name synonymous with TU football entered the basketball scene. While working as an assistant football coach under Sam McBirney, Francis Schmidt took the reigns for two seasons, compiling a 20-14 record. In 1917, Hal Mefford laid claim to both the football and basketball teams but faired poorly. Kendall didn't participate in the conference that season and recorded a dismal 1-5 record. Mefford was the first coach to take the team outside of the state of Oklahoma, playing games against Central Missouri State, Missouri, Illinois State, Sparks College (Shelbyville, Illinois), and Southern Illinois.

It just took one year for the program to turn around under the direction of the returning

Schmidt. After a 5-3 season in 1918–19, Schmidt nearly matched his football team's 8-0-1 mark with a 16-3 performance from his 1919–20 hoops squad. The team's success included an 11-0 romp through the Oklahoma Collegiate Conference and a school record 16 consecutive wins. In his last two seasons at the helm, the Cagers recorded 18-2 and 14-4 marks respectively. One of Schmidt's star players was team captain Ivan Grove, better known for his exploits on the football field and a TU Athletic Hall of Fame inductee. By the time Schmidt left to take a football position at Arkansas, he had compiled a six-year record of 73-26 and the second highest winning percentage in school history (.737). In his final season, Kendall College officially became known as The University of Tulsa.

Following Schmidt's departure, his football predecessor also took over the basketball team. Howard Acher led Tulsa into a pair of abbreviated seasons going a combined 3-4 including a road victory against Missouri. For the 1924–25 season, Tulsa jumped back into Oklahoma Collegiate Conference play and finished 11-6 en route to an overall 13-8 record. Acher's three seasons resulted in a combined 16-12 mark, but perhaps his more significant contribution was a new nickname. During the football season, Acher dubbed his team the Golden Tornadoes. Georgia Tech was already using that name, so the moniker was later changed to the Golden Hurricane.

Tulsa struggled for the next five seasons under J.B. Miller. During that time, he coached the team to an overall 16-45 record and the team never played outside the state of Oklahoma. In 1929–30, Miller ushered in the short-lived Big Four Conference along with Oklahoma City, Oklahoma Baptist and Phillips. Two-year coach Oliver Hodge took over in 1930–31 and compiled a 20-11 record. His teams inaugurated longstanding rivalries with Wichita State (splitting a pair of games) and Arkansas (losing both contests). One of Hodge's star players was future TU Hall of Fame athlete Ishmael Pilkington, noted mostly for his football career.

In 1932, former football and basketball star Chet Benefiel embarked on the longest coaching tenure of the program's first 40 years. Initially, Tulsa continued in the Big Four Conference, but in 1934 the Hurricane joined the new Missouri Valley Conference, an affiliation that TU would continue for 61 years. Benefiel's career was consistently inconsistent. He led the 1932–33 squad to an 11-6 mark before enduring three non-winning seasons (the 1936–37 team was 9-9). Benefiel bounced back with two winning seasons (12-10 in 1937–38 and 15-8 in 1938–39) and finished with an overall 65-65 record. The following year he took over as Tulsa's head football coach.

Over the next 10 years, Tulsa rode the coaching carrousel as seven different coaches took turns holding the reins. The Hurricane was only able to garner winning seasons in 1940–41 under Jack Sterrett (12-9) and in 1943–44 under Woody West (5-3). TU also suffered its only season without a victory in 1942–43 when Mike Milligan's team went 0-10. At the same time, other state schools were enjoying national success. Oklahoma State won back-to-back championships in 1945 and 1946 and was the runner-up in 1949. Oklahoma was the national runner-up in 1947. Under Head Coach John Garrison, Tulsa had its own brush with greatness when the team opened the 1947-48 season with a pair of lopsided losses to eventual national champion Kentucky. In 1948–49, TU again traveled to Lexington, KY, and was drubbed 81-27 by the Wildcats, who would successfully defend their title later that year.

After setting trends in the early 1900s, The University of Tulsa now found itself mired in the quicksand of mediocrity. It would take an up-and-coming coach with a legendary last name to help put the program back on solid ground.

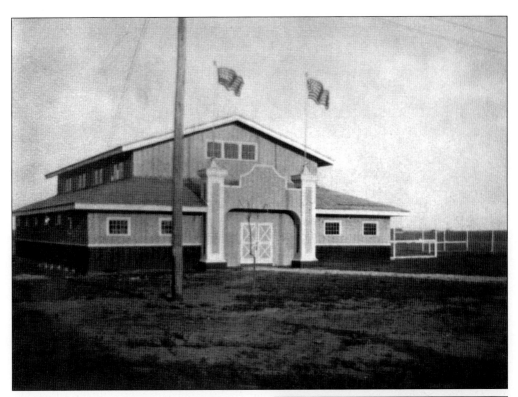

Pictured is the Kendall Gym. The building served as the temporary home court for Kendall College basketball during the 1913–14 season. (Courtesy of The University of Tulsa.)

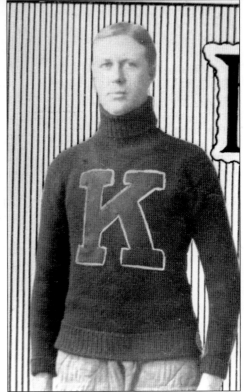

Harvey Allen coached the 1913–14 squad to a 3-2 record, playing games against Methodist Indian School and Claremore Prep. (Courtesy of The University of Tulsa.)

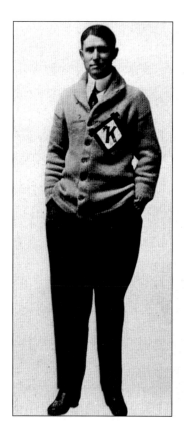

Forest Rees coached the 1914–15 Kendall College team to a 6-3 record. Playing in the Oklahoma Collegiate Conference, the Kendallites went 4-0 against Oklahoma State and 1-3 against Oklahoma. (Courtesy of The University of Tulsa.)

Francis Schmidt served as Kendall College's head coach from 1915 to 1917, and then again from 1918 to 1922. Known more for his tenure as the head football coach, Schmidt was equally successful on the basketball court. In six seasons, he led the team to a 73-26 record for a .737 winning percentage (second-best in school history). Schmidt's best season was in 1920–21 when the Kendallites went 18-2, including an 11-1 mark in the Oklahoma Collegiate Conference and an appearance in the National AAU Tournament. (Courtesy of The University of Tulsa.)

The 1915–16 team recorded a 9-7 mark in Francis Schmidt's first season at the helm. Pictured, from left to right, are (standing) Louis Pappon, Head Coach Francis Schmidt and Henry Waters; (seated) Everett Ziest, John Young, Ivan Grove and Ralph Handley. (Courtesy of The University of Tulsa.)

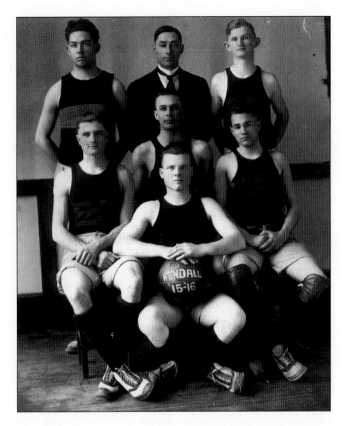

Hal Mefford coached Kendall College during the 1917–18 season. Mefford went 1-5 with the team's only victory coming at the expense of Tulsa YMCA, 45-33. Mefford's stint marked the first time in school history that the basketball team traveled outside the state of Oklahoma. Kendall College lost games on the road at Central Missouri State, Missouri, Illinois State, Sparks College (Shelbyville, IL) and Southern Illinois. (Courtesy of The University of Tulsa.)

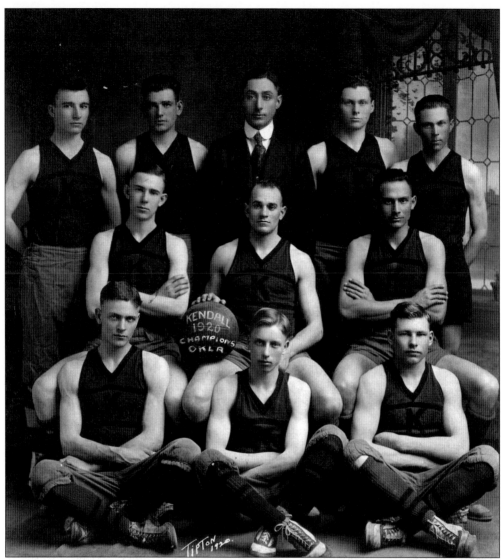

The 1919–20 team went 16-3 overall and 11-0 in the Oklahoma Collegiate Conference. Kendall College also registered a pair of victories against Oklahoma State. The team's 16-game winning streak from January 17 to March 13 still stands as a school record for most consecutive victories. Pictured, from left to right, are (front row) Paul Dunham, Ralph Lamb and Charles Keck; (middle row) Harold Balcom, Ivan Grove and Oscar Williams; (top row) Charles Pishney, Phillip Irvin, Head Coach Francis Schmidt, Hawley Kerr and Joyce Handley. (Courtesy of The University of Tulsa.)

Pictured is the 1919–20 Henry Kendall Academy team. These prep school athletes competed against area high school teams including wins against Skitaook (43-22) and Broken Arrow (45-28). Star players for the squad included Conrad Robertson, Edwin Steiner, Lloyd Melone, Percy Gray and Jack Albright. (Courtesy of The University of Tulsa.)

The 1921–22 team was the first to play under the school's new name. In Francis Schmidt's final season, The University of Tulsa posted a 14-4 record including four victories against Oklahoma State. (Courtesy of The University of Tulsa.)

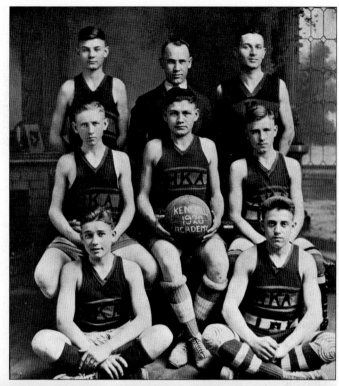

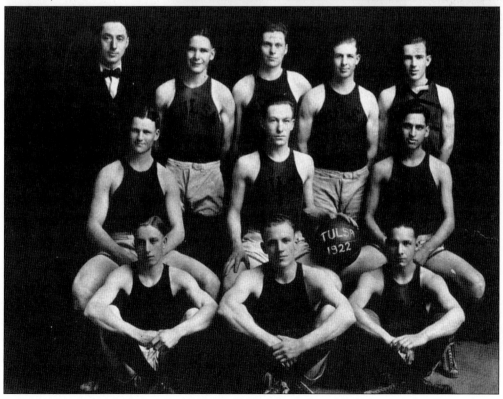

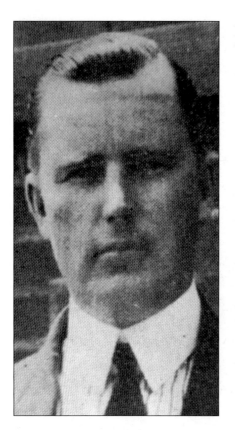

Howard Acher was Tulsa's head coach from 1922 to 1925. He compiled a 16-12 record including a 13-8 mark during his final season in 1924–25. (Courtesy of The University of Tulsa.)

J.B. Miller spent five seasons at the helm of TU basketball from 1925 to 1930. He recorded a career 16-45 mark and never took the team outside of the state of Oklahoma. His best season was in 1925–26 when Tulsa went 7-10 with all 17 games played in the Oklahoma Collegiate Conference. Miller's last season at TU was the school's first in the Big Four Conference with fellow competitors Oklahoma City, Oklahoma Baptist and Phillips. (Courtesy of The University of Tulsa.)

Oliver Hodge served as TU's head coach from 1930 to 1932. In two seasons, he led Tulsa to a combined 20-11 record including 9-3 in the Big Four Conference. (Courtesy of The University of Tulsa.)

The 1930–31 team went 10-4 in Oliver Hodge's first season at TU, including a 4-2 mark in the Big Four Conference and a pair of victories against both Wichita State and Drake. Pictured, from left to right, are (front row) Hiriam Alexander, LaRue Finley, Ed Dubie, Don Bailey and Leo Howard; (middle row) Ishmael Pilkington, Bill Pringle, Preston Littrell and Chet Benefiel; (back row) Tom Grisham, Fred Wick, Head Coach Oliver Hodge, William Whiteside and Fred Perry. (Courtesy of The University of Tulsa.)

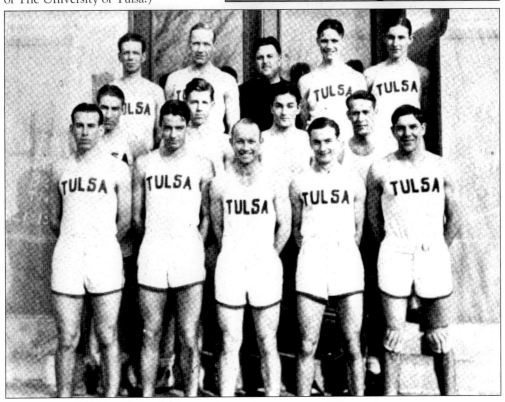

Former football and basketball star Chet Benefiel coached his alma mater from 1932 to 1939. Benefiel led TU to a 65-65 record over seven seasons and ushered the Golden Hurricane into the Missouri Valley Conference era in 1934–34. Benefiel's best season was his last in 1938–39 when Tulsa went 15-8 overall and 8-6 in the MVC. He also coached Herb Larsen, Tulsa's first All-MVC selection in 1934–35. Benefiel was inducted into TU's Athletic Hall of Fame in 1983. (Courtesy of The University of Tulsa.)

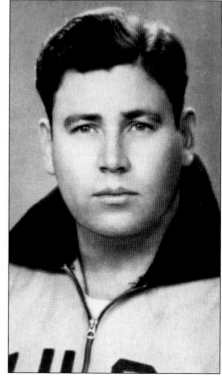

H.B. "Tex" Ryon was TU's head coach during the 1939–40 season and the 1941–42 season. He compiled a 15-28 career record. Ryon's best effort was in his first year when TU went 12-15 including a pair of MVC victories against St. Louis. (Courtesy of The University of Tulsa.)

18

Mike Milligan served as Tulsa's head coach for the 1942–43 season. Milligan went 0-10 marking the only time in school history that a team failed to win at least one game. (Courtesy of The University of Tulsa.)

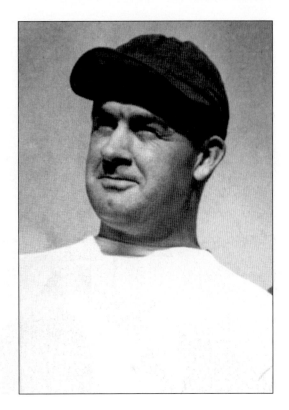

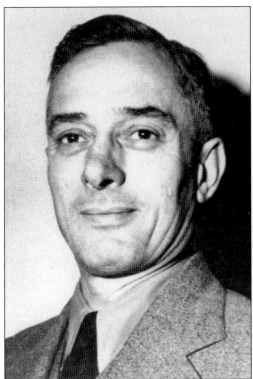

Paul Alyea was the Golden Hurricane head coach during the 1944–45 campaign. In his only season at the helm, Alyea went 4-8 overall in a shortened season. MVC competition was cancelled that year because of World War II. In the first year during which scoring records were kept, Barney White led TU, scoring 112 points in 12 games for a 9.3 average. (Courtesy of The University of Tulsa.)

Don Shields was TU's head coach from 1945 to 1947. Shields guided the Golden Hurricane to an 11-31 record in two seasons. He coached All-MVC selection Gerald Carrens in the 1945-46 season as TU posted a 6-12 mark. (Courtesy of The University of Tulsa.)

John Garrison served as Tulsa's head coach from 1947 to 1949. He led TU to an 11-36 overall mark including a career-best 7-16 record in his first year. Garrison embarked on one of TU's most demanding schedules including three games at Kentucky, a road contest at Tennessee and MVC matchups against Oklahoma State, St. Louis and Bradley. (Courtesy of The University of Tulsa.)

TWO
History Makers
1949–1960

When most basketball fans hear the name "Iba," usually the first name "Henry" comes to mind. After all, Henry Iba is still known as one of the greatest college basketball coaches to roam the sidelines. He led Oklahoma State to three national championship games and two national titles. But for longstanding followers of The University of Tulsa hoops program, it was another Iba that made a significant impact.

Clarence Iba was the brother of Henry Iba. Overshadowed by his sibling's exploits, Iba quietly took the challenge of bringing Tulsa to national prominence. Hall of Fame member Jim King was a freshman at Tulsa during Iba's last season. Although he never played a game for the man, he recalls his meticulous coaching style. "He was a talker," King says. "He talked a lot. He'd let you run a play then he'd stop and talk for five minutes. I'd never played under a coach like that."

While the formula was frustrating to some players who preferred a faster paced style, Iba's patient half-court mentality on offense helped restore confidence in TU basketball and even took it to new heights. In his first season alone, Iba guided the Hurricane to a 12-11 season following the dismal 4-20 team from 1948–49. Tulsa still struggled in the competitive Missouri Valley, but did show signs of improvement with victories against Wichita State and Bradley. All-MVC performer and TU Hall of Fame inductee Neil Ridley was the team's leading scorer that season.

During the 1950–51 campaign, Tulsa recorded an overall 10-17 mark and again dealt with life in a tough conference, finishing in a tie for sixth. The 1951–52 season, however, would represent the beginning of a five-year winning streak. Tulsa opened up with a 48-46 home loss against SMU. The Hurricane then reeled off six straight wins that included victories over Missouri, Alabama, #18 Oklahoma City and two against Arkansas. Tulsa went 5-5 in MVC play that year, but, more importantly, notched arguably the biggest upset of Iba's career. Led by future Hall of Famers Dick Nunneley and Warren Shackelford, the Golden Hurricane helped Iba defeat his brother's #16-ranked Oklahoma State squad.

The 1952–53 team took TU basketball to a new level of achievement. While the team's 15-10 record wasn't the most sparkling on paper, upsets of #10-ranked Louisiana State and #18-ranked Oklahoma City caught the eye of postseason decision makers. Tulsa had also won key games against Wichita State, St. Louis and Houston en route to a 5-5 conference record. The

reward was the first-ever trip to the NIT, where the Hurricane lost 89-60 to Duquesne. TU also earned its first national ranking and was ranked eight of 14 weeks including a spot at the #8 position. Nunneley and Shackelford repeated their All-MVC performances from a year earlier as they paced the squad in scoring and rebounding.

In 1953–54, Tulsa again went 5-5 in the conference and recorded an overall 15-14 mark including wins against Arkansas, Utah, Cincinnati, Mississippi and an upset of MVC rival #18-ranked Bradley. That season saw the emergence of a future star. Bob Patterson was already a junior, but had stayed under the radar thanks to his talented teammates. The 1954–55 would prove to be a breakout year for both he and his overachieving team.

By the time Tulsa reached conference play, the team had compiled an 8-4 mark with key wins against Texas A&M, Arkansas, Baylor and Arizona, plus a pair of victories against in-state rival Oklahoma City. By February 15, the Hurricane was 6-1 in the MVC and in the national rankings at #19. Tulsa had already defeated Oklahoma State in Stillwater and with the Cowboys visiting the Fairground Pavilion, a run for the title seemed imminent. Unfortunately, OSU temporarily derailed TU with a 62-52 loss, but Tulsa bounced back to win its last three conference claim (including a 76-62 defeat of St. Louis) and finished tied with St. Louis for first place with an 8-2 mark, the best of Iba's career.

Tulsa made history that season by receiving its first invitation to play in the NCAA Tournament. The #16-ranked team was upset in the first round by Colorado, 69-59, but won its consolation game against SMU, 68-67. TU finished 21-7 and Iba was named MVC Coach of the Year. Patterson and Dick Courter earned All-MVC honors. Patterson was named to the NCAA Western Regional team and became Tulsa's first All-American. His 773-point performance still stands as the school's second-best season total as does his 27.6 per game scoring average. Patterson was also the first Hurricane player to be drafted into the NBA, where he played with the Boston Celtics.

In 1955–56, the Hurricane performed admirably in the wake of heightened expectations. The team received a #15 ranking in January following an upset of #10-ranked Oklahoma City. Other key non-conference wins included Texas A&M, UTEP, Western Kentucky, TCU and two against Arkansas. But the MVC returned to its challenging form and Tulsa finished fifth with a 4-8 record. The team's 16-10 overall mark was highlighted by a 46-42 upset of #20-ranked Oklahoma State and a rare two-game sweep of Bradley.

The final four seasons of Iba's 11-year tenure were a struggle. Tulsa compiled a combined 34-68 record and never finished higher than fifth place in the MVC. TU's best effort during that time was a 10-15 record in 1958–59. The Hurricane defeated Arizona State, Oklahoma State and Arkansas twice. Individual bright spots included players like TU Hall of Famer Roger Wendel who earned back-to-back All-MVC honors (1957–58 and 1958–59). Future stars like Gene Estes and David Voss also entered the program, although neither would truly blossom until later in their careers.

When Iba retired after the 1959–60 season, he walked away with an overall record of 137-147 and the most wins of any TU coach. He led the Hurricane to its first NIT and NCAA appearances, first national ranking and defeated seven nationally-ranked opponents. Iba also dramatically increased the level of talent. More importantly, he left a lasting legacy that would inspire future coaches to strive for excellence.

Opposite: The 1950–51 team recorded a 10-17 mark but did manage to take one of three games from Arkansas and a pair of victories against Houston. Pictured, from left to right, are (front row) Bill Wille, Tom Holliday, Gerald Rosendahl, Glenn Dille and Larry Whiteley; (middle row) Head Coach Clarence Iba, Jack Nolen, Marcus Arrington, Gale Welch and Student Coach Mac Duckworth; (back row), Manager Jim Pumpelly, Warren Shackelford, Don Scarbrough, Don Cannon, Neil Ridley and Trainer W.M. "Doc" Jenkins, (Courtesy of The University of Tulsa.)

Clarence Iba served as TU's head coach from 1949 to 1960. Iba coached the Golden Hurricane longer than any other coach in Tulsa history and produced the most wins. In 11 seasons, he compiled a 137-147 overall record and led TU to its first NIT appearance and national ranking (1953) and TU's first NCAA appearance (1955). Iba was named MVC Coach of the Year in 1954–55 and coached Tulsa's first All-American and pro draftee (Bob Patterson). Throughout his career, he had 14 All-MVC athletes on his teams. In 1994, Iba was inducted into TU's Athletic Hall of Fame. (Courtesy of The University of Tulsa.)

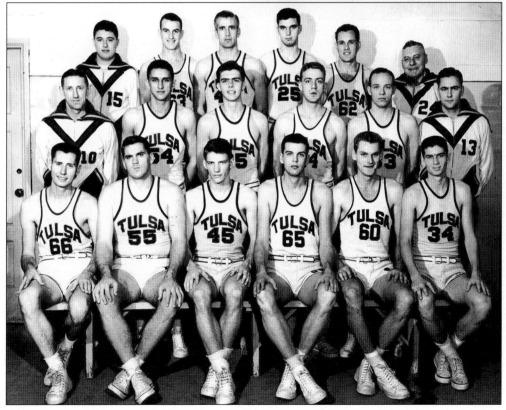

Neil Ridley played for the Golden Hurricane from 1948 to 1951. Ridley was TU's leading scorer in all three seasons and finished his career with 779 points for a 10.5 average. As a junior, he was named to the All-MVC Team. Ridley was inducted into TU's Athletic Hall of Fame in 1995. (Courtesy of The University of Tulsa.)

The 1951–52 team recorded a 14-10 overall mark and 6-6 effort in the Missouri Valley Conference. Tulsa defeated Alabama and Missouri, took a pair from Arkansas and Bradley, and split its two-game series with Oklahoma State. Pictured, from left to right, are (front row) Don Gore, Dick Nunneley, Warren Shackelford, Bob Mesac and Jerry Andress; (middle row) Jack Nolen, Marcus Arrington, Jack Hensley, Don Cannon, Ellis Jenkins and Tom Holliday; (back row) Bill Wille, Gerry Rosendahl, Glenn Dille, Dick Courter, Larry Whiteley, Assistant Coach Joe Swank and Head Coach Clarence Iba. (Courtesy of The University of Tulsa.)

The 1952–53 squad was the first in school history to earn a bid to play in the NIT. TU finished 15-10 on the season and tied for second in the MVC. Season highlights included a pair of victories against Arkansas and an upset of #10-ranked Louisiana State, 84-58. TU was ranked #15 at the time. Pictured, from left to right, are (front row) Warren Shackelford, Don Gore, Charlie Archambo, Ernie Stewart, Red Andress, Dick Nunneley, Jerry Hacker and Bill Elliott; (middle row) Ellis Jeankins, Jerry Rosendahl, John Jobe, R.J. Robbins, Jack Nolan, Tom Holliday and Bob Patterson; (back row) Assistant Coach Joe Swank, Jack Hensley, Marcus Arrington, Dick Courter, Glen Dille, Larry Whiteley, Bob Mesac and Head Coach Clarence Iba. (Courtesy of The University of Tulsa.)

Warren Shackelford played for TU from 1949 to 1953. He earned back-to-back All-MVC honors as a junior and senior. In 1952–53, Shackelford led Tulsa in rebounding with 161 boards for a 6.4 average. The previous year, he led the team in both field goal and free throw percentages. Shackelford was inducted into TU's Athletic Hall of Fame in 1994. (Courtesy of The University of Tulsa.)

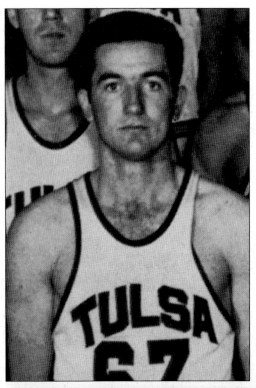

Dick Nunneley played for the Golden Hurricane from 1951 to 1954. Nunneley led TU in scoring as a sophomore (15.8 ppg), junior (13.1 ppg) and senior (17.3). He was also a three-time All-MVC performer. In 1953–54, Nunneley became the first player in Tulsa history to score more than 500 points. His 504 points stands as the 30th best single season performance for all TU players and he ranks 16th on TU's all-time scoring chart with 1,213 points for a 15.6 average. In 1985, Nunneley was inducted into TU's Athletic Hall of Fame. (Courtesy of The University of Tulsa.)

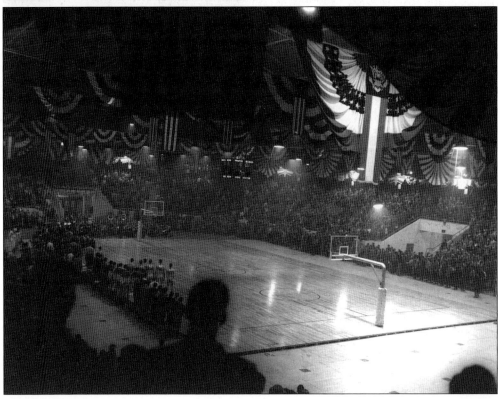

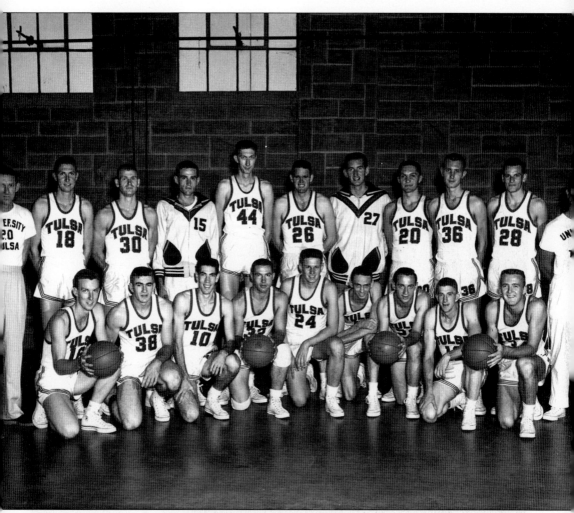

The 1954–55 team earned Tulsa's first ever appearance in the NCAA tournament. The Golden Hurricane finished 21-7, with an 8-2 MVC record and tie for first place. Key victories included Texas A&M, Arkansas, Arizona, Oklahoma State, St. Louis and Bradley. Tulsa lost its opening round NCAA game against Colorado (69-59) but bounced back to claim its consolation game against SMU (68-67). Pictured, from left to right, are (front row) John Jobe, Jim Duncan, Don Denton, Junior Born, Duane Downer, Jerry Hacker, Ernie Stewart, Jerry Evans and William Elliott; (back row) Head Coach Clarence Iba, Dick Courter, Bob Patterson, Mel Johnson, Ken Leatherman, Jim Krause, Richard Bischoff, John Wenzell, John Yates, John Stob and Assistant Coach Joe Swank. (Courtesy of The University of Tulsa.)

Opposite: The Golden Hurricane joins the crowd in the traditional pre-game singing of the National Anthem before its February 19, 1955 meeting with Notre Dame. Tulsa defeated the Fighting Irish 74-59 at the Fairgrounds Pavilion. The Fairgrounds hosted TU basketball from 1950 to 1977 where the Golden Hurricane recorded an overall mark of 243-128. The biggest upset in TU's history took place at the Pavilion when Ken Hayes' squad defeated #3-ranked Louisville 84-77 on February 8, 1975. (Courtesy of The University of Tulsa.)

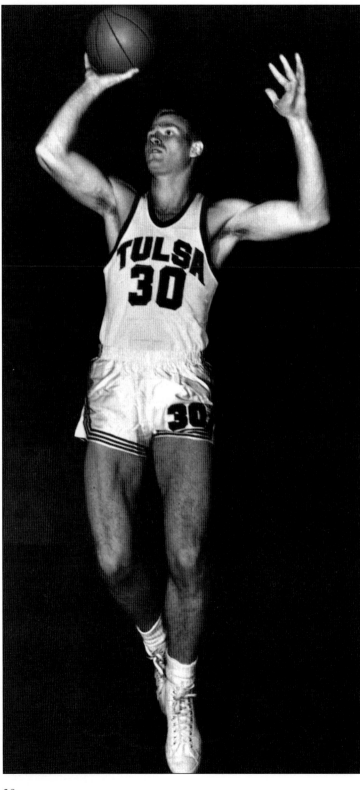

Bob Patterson played for The University of Tulsa from 1951 to 1955. As a senior, he led the Golden Hurricane in scoring and rebounding. His 370 rebounds and 13.2 per game average still stand as a TU single-season records. Patterson was named MVC Player of the Year and was Tulsa's first All-American. He is eighth on TU's all-time scoring list with 1,440 points and 10th on the all-time rebounding chart with 683 boards. He was Tulsa's first player to break the 700-point barrier when he scored 773 points (27.6 ppg) during the 1954–55 season. He holds TU's single season record for free throws made (229) and free throws attempted (297). Patterson was the first Golden Hurricane player to be drafted by the NBA where he spent several years starring for the Boston Celtics. In 1982, he joined Glenn Dobbs and Ivan Grove as the first group of inductees into Tulsa's Athletic Hall of Fame. Patterson's #30 jersey is retired. (Courtesy of The University of Tulsa.)

Junior Born leaps for a rebound as Dick Courter looks on during Tulsa's 76-62 victory against St. Louis on February 26, 1955. During the 1955–56 season, Born led TU in scoring with 381 points for a 14.6 average. (Courtesy of The University of Tulsa.)

Dick Courter attempts to tip the rebound away from a St. Louis opponent. Courter played for Tulsa from 1951 to 1955. Despite the fact that he was never recorded as the single-season leader in rebounds, he ranks 16th on the school's all-time rebounding chart with 624 for a 5.9 per game average. (Courtesy of The University of Tulsa.)

Dick Courter was a key player in TU's first appearances in the NIT (1953) and NCAA tournament (1955). As a senior, he joined Bob Patterson as one of Tulsa's two selections to the All-MVC Team. He was also a star on the track and field team and won the MVC high jump championship in 1954. Courter was inducted into TU's Athletic Hall of Fame in 1992. (Courtesy of The University of Tulsa.)

Jerry Hacker takes a baseline jump shot in Tulsa's 65-58 victory against Oklahoma City University on December 29, 1955 at the All-College Tournament. The win secured the Golden Hurricane's first team title at an in-season tournament. (Courtesy of The University of Tulsa.)

Clester Harrington played for TU from 1955 to 1958. Harrington led TU in rebounding as a sophomore (6.7 rpg) and junior (10.0 rpg). He is ranked 11th on Tulsa's all-time rebounding chart with 662 boards for an 8.6 average. (Courtesy of The University of Tulsa.)

Roger Wendel played for Tulsa from 1955 to 1958. He led TU in scoring as a junior (17.5 ppg) and senior (18.8 ppg). Wendel was also a two-time All-MVC selection and is ranked 20th on the school's all-time scoring chart with 1,121 points for a 14.8 average. In 2000, he was inducted into TU's Athletic Hall of Fame. (Courtesy of The University of Tulsa.)

Bob Goodall played for the Golden Hurricane from 1957 to 1960. He led TU in rebounding as a sophomore with 303 boards (11.6 rpg) and as a junior with 266 rebounds (10.6 rpg). Goodall is one of just five TU players to collect more than 300 rebounds in a season. He is ranked second on the all-time rebounding chart with 782 boards for a 10.3 average (second best in school history). (Courtesy of The University of Tulsa.)

David Voss played for TU from 1958 to 1961. Voss led Tulsa in scoring as a junior with 396 points (15.2 ppg) and as a senior with 416 points (16.6 ppg). He is ranked 26th on TU's all-time scoring chart with 1,074 points for a 14.3 average. A two-time All-MVC selection, Voss was inducted into TU's Athletic Hall of Fame in 2000. (Courtesy of The University of Tulsa.)

THREE
The Valley of Death
1960–1980

As the Clarence Iba era was ending, cosmetic changes were taking place in the Missouri Valley Conference as well. In 1957, Oklahoma State left the MVC but was promptly replaced by Cincinnati, a rising powerhouse that would claim national titles in 1961 and 1962. Louisville would further strengthen the conference by joining in 1964.

When Joe Swank took over for the retiring Iba in 1960, not only did he have to replace a popular mainstay of TU athletics, he was also forced to deal with the prospects of playing in the "Valley of Death." Sports Illustrated gave the MVC this dubious nickname thanks to its brutal road schedule that included trips to Cincinnati, St. Louis, Wichita, Omaha, Peoria and Des Moines. Swank had previously spent several years on Iba's staff as an assistant and was responsible for many of the team's recruiting successes. That included a relatively unknown player from Fort Smith, AR, named Jim King.

When Swank visited Fort Smith, he was there to recruit Tommy Boyer. Although Boyer ultimately decided to play for Arkansas, Swank didn't come back empty handed. He had found a gem in King, who, as a senior, had just found his way into the starting lineup. By the time he got to Tulsa, King had already earned the nickname "Country" thanks to his upbringing on a farm.

"When we moved to town, there were six of us kids and we had a cow and chickens and I had my hunting dogs," King says. "When my teammates would come out to my house, I'd be out milking or something. They started calling me 'Country Boy.' That followed me over here and Coach Swank picked up on it real early."

King developed an early appreciation for Swank's coaching style. His up-tempo, fast breaking brand of basketball was a sharp contrast to Iba's slow-down, half court offense. Swank coached King as a member of the freshman team during the 1959-60 season. "He was a running coach and he had very little to say," King recalls. "His [American] Indian background didn't make him a talker. He just wanted us to play and play hard and play good defense and really get after it. I have to give him credit for giving me the freedom to do things I'd never dreamed I could do in a game."

Swank's first season in 1960–61 was King's sophomore year and his first opportunity to play on the varsity team. A year earlier, he had watched from the sidelines as Oscar Robertson and Cincinnati handed the Hurricane a 33-point loss. Most of the other teams were bigger and

included talented Black athletes that Tulsa had yet to integrate into its athletic programs. But King was able to share one year on the court with Gene Estes and David Voss. Voss was a two-time All-MVC performer and was later inducted into TU's Athletic Hall of Fame. King believes Estes is likewise worthy of that prestigious honor.

"He was probably one of the best rebounders that Tulsa has ever known," King says. "Gene was a fighter. He was a six-six guy playing against bigger guys most every night, but he held his own and really did better than that."

The season opener welcomed John Wooden and his UCLA Bruins to the Fairgrounds Pavilion. Wooden was still three years away from his first of 10 national championships but the #13-ranked squad still presented a formidable challenge. The Bruins prevailed 94-74. Tulsa went on to finish at 8-17, but did manage victories against Oklahoma State and Arkansas.

With Estes and Voss gone from the lineup, King was forced to fill two pairs of sneakers. He led the 1961–62 team with 18.4 points and 8.5 rebounds per game. Ultimately, the lack of depth and an even tougher schedule than the year before led to a 7-19 record and sixth place conference finish. King was named All-MVC for his efforts, but desperately needed help to carry the load.

As far as King is concerned, Bill Kusleika's arrival on campus was the equivalent of the cavalry coming to save the day. The Bacone Junior College transfer provided a spark on both ends of the court and some much needed relief for King.

"Kusleika was incredible," King says. "He was a scoring machine around the basket. He made everybody else better. He used me better than anybody ever did. We didn't keep assists in those days, but I probably averaged 10 a game just off Bill. He wasn't a great shooter, but he was a thrower with a touch. He was the most unorthodox player that ever played the game at that level."

King and Kusleika teamed up to lead the 1962–63 team to its first winning season in seven years. On the way to a 17-8 record, Tulsa notched victories against Purdue and Florida and two wins each against Arkansas and Houston. TU hit a milestone early in the season when the Hurricane reached the 100-point mark in a game for the first time in school history. King scored a career-high 39 points as Tulsa defeated Adams State 107-54.

But it was the following game that would be most remembered. Los Angeles State came to Tulsa under the direction of former Boston Celtic great Bill Sharman, a coach that King would later play for with the NBA's San Francisco Warriors. Sharman decided to dramatically slow down the pace of the game by using "an old Iba trick." TU won the game, but the 53-44 final score paled in comparison to the previous contest.

"[Los Angeles State] came in and held the ball and there ended up being a fight at the end of the game because the people were so mad," King says. "The people just hated it. We had a running team and the people came out to see us score all of these points. The people were just totally hostile. Right after the game, it was like a brawl. I'll never forget talking to Bill Sharman after the game and apologizing for the fans. I was embarrassed by it."

Just four games into the conference season, TU was sitting at 1-3 and desperately needed a win. The prospects weren't good when #7-ranked Wichita State came to town on January 15. King remembers those games against the Shockers as very heated with a strong hatred between fans. For that reason, this meeting didn't seem any different than the past. Perhaps it was that attitude that helped Tulsa overcome Wichita State 85-83 in double overtime. The victory is tied for the third biggest upset in school history.

With three games left in the season, Tulsa nearly pulled off a miracle win on the road against top-ranked Cincinnati. King recalls the final seconds of that contest: "We led the whole game and had a chance to win it," he says. "They had the last shot. I thought we had them beat. We all did. We outplayed them totally. They took a shot and George Wilson who played center for them tipped the shot in. He wasn't a scorer at all, but he tipped in a shot at the buzzer and beat us. That was a heartbreaking loss because we felt like we were making some strides and becoming a good team and maybe had a chance to make the NIT."

34

Instead, TU would fall short of a postseason bid. At that time, only 32 teams made it into the NCAA tournament, leaving a logjam of great teams to contend for 16 spots in the NIT. Kusleika led the team in scoring (17.1 average) and rebounding (8.7 average) that year. He and King were both named All-MVC performers and King made the All-American honorable mention list.

One thing that King had always regretted was not having the opportunity to play with Black athletes. While most other teams in the MVC had already begun to integrate their programs, key figures working behind the scenes weren't willing to take that step. That all changed just as King was ending his career. He helped Swank recruit two of the first Black athletes to play at TU. Herman Callands and Sherman Dillard were later joined by Eldridge Webb and Julian Hammond. That quartet of players saw its first action during the 1964–65 season. Football coach Glenn Dobbs was also working to break the color barrier by recruiting Black players such as Ed Buchanan, who hid out in the dorms while the administration attempted to clear him for admission. King, a skilled barber since high school, gave Buchanan haircuts and the two became good friends.

"It wasn't that Swank didn't want to recruit Black players," King says. "It was some of the donors who just didn't want Black athletes at The University of Tulsa. It was starting to change, but not everybody was ready for it."

After a disappointing 1963–64 season in which the Hurricane went 10-15, Swank's crew put it back together in 1964–65 thanks to the senior leadership of Rick Park and the addition of Callands, Dillard, Webb and Hammond. Tulsa opened the season with an upset of #15-ranked Seattle, 98-76. Later in the year, the Hurricane stepped out of conference play and upended #8-ranked San Francisco, 59-53. Swank became the first coach in TU history to defeat three ranked opponents in one season with a late season upset of #10-ranked Wichita State. Inconsistency plagued the team, however, and Tulsa finished 14-11 overall and 7-7 in the MVC to tie for fifth place.

In 1965–66, Swank hired a young assistant coach named Ken Hayes. Previously, he had spent time coaching at Bacone Junior College where he worked with future TU star Bill Kusleika. That year, the Hurricane went 16-13 overall and finished sixth in the MVC with a 6-8 mark. Tulsa continued to pull off impressive upsets including an early season toppling of #10-ranked Kansas State and a stellar defeat of #7-ranked Michigan at the Rainbow Classic in Honolulu. Michigan was the national runner-up just one year earlier. TU went on to defeat MVC rival St. Louis in the championship game to win the Rainbow Classic title. Other key victories came against Washington, Louisville, Cincinnati and Bradley.

The following year proved to be Swank's best yet. Tulsa posted non-conference victories against Wyoming, Hawaii and Yale and upset #8-ranked Cincinnati en route to a series sweep. TU also posted a pair of wins against both Bradley and Wichita State and finished second in the MVC with a 10-4 record. The Hurricane earned the school's second NIT bid and faced New York native Coach Al McGuire and his Marquette team in the first round. Tulsa fell short 64-60 and ended the season with a 19-8 mark. Swank was named MVC Coach of the Year and junior Eldridge Webb received All-MVC honors.

Considering the talent that Swank had returning for the 1967–68 season, it was conceivable that the Hurricane could repeat its success of the year before. Bobby Smith, Al Cueto, Larry Cheatham, Ron Carson, Doug Robinson, Rob Washington and Eldridge Webb provided a potent combination of scorers and defensive stalwarts. The team got off to a great start winning nine of its first 11 games, including conference victories against Memphis State and Cincinnati. But the Hurricane fell apart in the second half the season losing 10 of its last 12 for a final record of 11-12 overall and 5-11 in the MVC finishing second to last (seventh place). The disappointing effort also broke TU's 10-year string of All-MVC performers.

By the end of the 1968–69 season, Hayes had decided to make the leap to head coaching. The Centenary job was open and he approached Swank to get his blessing. "I was very comfortable as an assistant, but like all young coaches, I wanted to sprout my wings. I'll never

forget on a Monday morning I went into Coach Swank's office and said, 'Coach, with your permission I'd like to apply for that Centenary job.' He was very hesitant in replying and shuffled that Skoal around his lower lip a few times and he finally looked at me and said, 'Ken, that's where I've been all weekend. I've been in St. Louis and I've accepted the Centenary job."

Swank wanted Hayes to replace him but advised that they keep the matter quiet for a while so as not to jeopardize his chances. The plan worked and Hayes was named TU's 19th head coach. In his first season, Tulsa returned to the magic of the 1966–67 season and matched the win-loss record with a 19-8 mark. Led by the likes of Cueto, Smith and Washington, the Hurricane pulled off a feat that has yet to be repeated or bested. In early January, Tulsa defeated #10-ranked Cincinnati (57-50), #14-ranked Louisville (85-69) and #18-ranked Drake (86-78) in consecutive games. That string of high profile victories earned TU a #14 national ranking that eventually peaked at the #7 position.

Late season losses would cause the team to finish unranked, but Tulsa still managed to finish third in the MVC and earn its second NIT appearance in three years. TU traveled to New York where they lost to St. Peter's in the first round, 75-71. Bobby Smith was named MVC Player of the Year while Hayes earned MVC Coach of the Year in his first year at the helm. Despite the accolades, the season had a bittersweet ending as the team dropped six of its last seven games.

"That ball club at the end of the year became divided and as a young coach without any experience at all, I didn't know how to handle that situation," Hayes admits. Although we were invited to the NIT, it was a bad ending to a great season. Those were a bunch of great guys and I love them very much."

Hayes' sophomore season in 1969–70 was a rebuilding year. Future Hall of Famer Ron Carson was the only returning starter on a team that had lost Cheatham, Cueto, Smith and Washington. TU opened at #3-ranked Purdue and lost a tight 77-74 battle against a team that had lost to national champs UCLA in the Final Four a year earlier. The Hurricane finished fifth in the conference with an 8-8 record and overall 15-11 mark.

That same year, Tulsa had acquired a transfer from ORU named Dana Lewis. One of the most highly sought out recruits in the nation, the New Jersey native contacted Hayes and was also interested in USC. At first, ORU would not grant Lewis his release. That summer, he stayed in Tulsa and worked a job hauling hay. For the first semester, he paid his own way by working construction. Lewis was on the verge of leaving when Oral Roberts himself personally handed Hayes a handwritten letter of release.

In the 1970–71 game against Purdue, he blocked Rick Mount's last second shot attempt into the stands preserving a 100-98 victory. Lewis would leave for the NBA after his junior year where he signed a $700,000 contract with Philadelphia only to be cut before the season started. In his two years at Tulsa, he averaged 21.8 points and a school record 12.7 rebounds per game.

That season also saw the arrival of scoring sensation Steve Bracey. In a game against St. Louis, Hayes says Bracey was part of "the single most exciting play ever at the Fairground Pavilion." Tulsa was trailing by 10 points and St. Louis guard Joe Irving stole the ball. Bracey passed him before he got to the free throw line and Irving pulled up for a jump shot. Facing the basket, Bracey jumped and then turned his body in mid-air to spike ball with such force, it landed in the bleachers at mid-court.

"There was a hush that came over the crowd," Hayes recalls. "Then all of the sudden, I thought the roof was going to come off the place. They couldn't believe what they'd seen and they were stunned. St. Louis never recovered and we won the game [75-70]."

Tulsa went 17-9 that season and garnered upset victories against #16-ranked Drake (66-60) and #19-ranked Memphis State (90-85). The Hurricane also lost 95-75 against the #1-ranked UCLA Bruins that were in the middle of a seven-year NCAA title run. TU finished tied for fourth place in the MVC and Lewis led the conference in scoring en route to All-MVC and Honorable Mention All-American kudos.

In 1971–72, Tulsa's 15-11 record was enhanced by Bracey's individual achievements. He set a new school scoring record with 47 points against Drake on January 8, 1972 in Tulsa. Bracey

was named All-MVC and Honorable Mention All-American. He was drafted by the Atlanta Hawks along with teammate Jim Clesson and would later play with the Golden State Warriors.

The departure of Bracey and Clesson made way for one of TU's most prolific scorers. Willie Biles played a dominant role in Tulsa's 18-8 season and third place conference finish. The 1972–73 campaign would be a record-shattering year. By mid-February, Biles had already recorded four scoring performances of 40 points or more. He was flirting with Bracey's one-year old mark when TU traveled to play North Texas State. The fans and the media were harassing Hayes about letting Biles break the record. With 1:30 to go in the game, he had 46 points, just two shy of surpassing Bracey. Hayes put Biles back in the game and told him to "hit a couple and get 'em off my back."

"Coach, records don't mean anything to me," Biles replies. "We've got the game won and these guys work hard in practice. Now's their time to play."

Hayes put him back in the game and he refused to shoot the ball. He did hit a free throw to tie the record at 47 points. Two weeks later in the season ending game against Wichita State, Biles finally broke that record by scoring 48 points in a game where the team needed every single one. TU prevailed 97-91. Biles finished the season with a school-record 30.3 scoring average and earned the first of two All-American awards. After his senior season, he squandered an opportunity to play in the NBA and hit rock bottom. Drugs and alcohol overtook Biles for several years until he turned his life around. He now serves as the Parks and Recreation Director for the City of Memphis and is considered one of the most popular public figures there.

In 1973–74, a tall, lanky player named Ken Smith came to Tulsa. Hayes gave him the nickname "Grasshopper" and it stuck with him for years to come. Smith and Tulsa-native Zack Jones almost never made it onto TU's campus. For some inexplicable reason (Hayes believes it was due to increasingly stringent requirements), both received letters from the registrar two weeks before school started telling them that they would not be admitted. This was despite the fact that Smith and Jones brought with them respectable 2.9 and 2.8 GPA's. Hayes was not told about the letters and didn't realize what had happened until Smith called him. Hayes promptly marched to President Paschal Twyman's office to rectify the problem.

Smith would go on to earn All-MVC honors as a senior and played pro ball for San Antonio before traveling to England and Belgium. In Belgium, he played until he was 46 years old and is still considered a national hero. Jones also played overseas in France where he became a French citizen and popular radio broadcaster. The athlete that was narrowly admitted to The University of Tulsa now speaks five languages.

On March 4, 1974, Tulsa and Oral Roberts met for the first time. The game was five years in the making and both teams were having great seasons. TU was banged up following a hard-fought win on the road against West Texas State. Point guard Tim Carson had broken his foot and Bob Okreszik could barely breathe because of a severe case of the flu. Somehow, Tulsa managed to stay in the game with a hobbling Carson seeing significant playing time. With just seconds remaining, Carson shot an ill-advised 30-foot jump shot that found its mark. Tulsa won the game 85-84 when an ORU shot was blocked out of bounds and another missed the rim completely. ORU would go on to advance to the NCAA Tournament's Elite Eight.

As September 1974 approached, Hayes already knew this would be his last season at Tulsa. He was growing frustrated with playing at the Fairground Pavilion and having virtually no recruiting budget. His final record of 15-14 was statistically the worst of his career, but, as usual, included some notable victories. TU defeated Oklahoma, Arkansas and #9-ranked Pennsylvania. Hayes pulled off the biggest upset in school history with an 84-77 defeat of #3-ranked Louisville. In his final game, Tulsa came back from a 21-2 deficit to defeat ORU 91-83 at the Mabee Center. He had announced his resignation three days earlier.

"I didn't want our players to think they had to win that game for me to keep my job," Hayes says. "And if we lost, I didn't want people to think I'd resigned because we couldn't beat ORU. The University of Tulsa at that time was not a competitive situation. It was a great university

and a great city and we played in a conference that was dominated by great teams."

At the end of Hayes' tenure, he had strung together seven consecutive winning seasons for a 117-69 record. He coached six All-Americans, eight pro draft picks and won more games against ranked opponents than any TU coach (eight). He earned two MVC Coach of the Year awards and was the District V NABC Coach of the Year in 1972–73. Hayes performed admirably in one of the nation's toughest conferences and during a time when postseason bids were at a premium.

As Hayes was preparing to leave Tulsa for New Mexico State, a former player was making his own mark on the coaching world. Jim King had just wrapped up historic back-to-back winning seasons with the traveling exhibition team Athlete's in Action. Before that, he spent 10 years in the NBA with Los Angeles, San Francisco (Golden State), Cincinnati and Chicago. King fought through an injury-riddled career to play in an NBA Final and an NBA All-Star Game. When King was called about the TU job, he says he let his emotions overcome rational thought.

"I should have stayed where I was," King says. "I didn't get enough counsel before I came. I talked to Ken [Hayes] but I didn't listen to him. He left the cupboard pretty bare. A lot of guys had graduated. But the biggest challenge was the budget. There was no money to recruit with. My coaches were sleeping in their cars. They couldn't get a motel room. My attitude was wrong, but I thought we could win first and then we could get people to donate. I think that was the administration's attitude. They thought I was going to win just because of who I was."

King brought his old teammate Bill Kusleika back to Tulsa as an assistant and recruited another former player, Rick Park, to be a part of his staff. His inaugural season in 1975–76 started with great promise. Tulsa opened with a 75-59 victory over Oklahoma State and followed that up with a 71-66 defeat of Oklahoma in Norman. A humbling loss to St. Mary's coupled with a 70-69 defeat at the hands of ORU brought King back to earth. This was going to be a long season.

One highlight came late in the season as Tulsa defeated former coach Ken Hayes and his new team from New Mexico State 86-83. After finishing fourth in the MVC with a 4-8 record, Tulsa ended the season with a rematch against ORU. Senior Bob Okreszik was in rare form that night, hitting 12 of 12 field goal attempts and leading TU to an 87-78 victory. That same ORU squad went on to play in the NCAA Tournament where it lost to Kansas in the first round.

The 1976–77 season brought two significant changes. TU would play five of its 13 home games at the Convention Center located in downtown Tulsa. The next year would mark a permanent move to that location. Also, it was the first year for the Missouri Valley Conference Tournament. Otherwise, King's second year yielded a similar result to his rookie season as TU finished dead last in the MVC with an overall 7-20 record.

Massive injuries plagued King's third year at the helm. His roster was so depleted that he was forced to recruit players from the football team. Jerry Taylor actually started some games for TU and future NFL star Don Blackmon saw some court action as well. This made for an interesting situation when Tulsa traveled to play UNLV where Reggie Theus was the star on Jerry Tarkanian's team.

"We were down by one and Blackmon intercepts a pass at halfcourt and goes towards the basket," King remembers. "One UNLV guard gets down there and tries to get in front of him and take a charge. (Blackmon) jumps around him and in doing so it distracted him. He started to stuff it and he changed his mind at the last second and let it roll off his fingers. The ball went around and around and the buzzer went off and it fell off the rim. We had them beat and all he had to do was make the layup."

The 104-103 loss in double overtime was part of a seven-game losing streak to start the season. Tulsa made improvements towards the end of the season winning six of the last 10 games. The Hurricane narrowly missed the MVC semifinals with a 76-75 loss on the road against Hayes' New Mexico State squad. In his four seasons at Las Cruces, NM, Hayes got the better of King by winning eight of the teams' 10 meetings.

The 1978–79 campaign was the best of King's tenure. Tulsa finished just shy of a winning season with a 13-14 record. The Hurricane lost five games by five points or less, including overtime losses to Wichita State (94-93 in Tulsa) and Bradley (80-78 in Peoria). TU had a brush with greatness in two meetings with second-year MVC member Indiana State. The Sycamores were led by future NBA great Larry Bird, but, in Tulsa, he was held to just 13 points. Indiana State won the game 66-56 and ended the season by losing to Magic Johnson's Michigan State team in the national championship game.

Hoping to take some momentum into the 1979–80 season, King and his team kicked things off with a victory over UNC-Greensboro (73-51) and a road win against Oklahoma State (89-86). As the team trudged through conference play, Tulsa held a 6-12 record when King's collegiate coaching career was abruptly brought to an end. Assistant coach Bill Franey stepped in for King and compiled a 2-7 record to bring Tulsa's final season tally to 8-19.

"Obviously it wasn't any fun to go through that," King says. "No one was more disappointed than me. My dream was to come in and really bring the program to another level. Trying to do a job like that with no budget was foolish on my part, but I did it out of ignorance. It was not an easy time, but I don't have any regrets. It brought me back to Tulsa and I love Tulsa."

King's struggles exposed a slew of shortcomings in The University of Tulsa's athletic department. Serious issues with funding and facilities were the culprits behind the former All-American's demise. It would take a very special set of circumstances to put the Hurricane back on the map.

Pictured, from left to right are (standing) Assistant Coach Jim Killingsworth and Head Coach Joe Swank; (kneeling) Jim King and Gary Hevelone. Joe Swank served as TU's head coach from 1960 to 1968. He previously worked as an assistant under Clarence Iba before leading Tulsa to a 102-103 combined record in eight seasons. Swank's best year was in 1966–67 when TU went 19-8 and finished second in the MVC. The Golden Hurricane also earned its second appearance in the NIT. Swank coached three All-Americans, eight All-MVC performers and five pro draftees. He was named MVC Coach of the Year following the 1966–67 season. Swank had a 7-16 record against ranked opponents including the 85-83 upset of #7-ranked Wichita State on January 15, 1963 and the 78-67 upset of #7-ranked Michigan on December 28, 1965. He coached TU to its first 100-point game when the Golden Hurricane defeated Adams State (CO) 107-54. Swank ranks fifth in wins among all Tulsa coaches. (Courtesy of The University of Tulsa.)

Jim "Country" King played for TU from 1959 to 1963. As a junior, King led the Golden Hurricane in scoring with 18.4 points per game and rebounding with 8.5 rebounds per game. He is ranked 21st on TU's all-time scoring chart with 1,119 points (14.7 ppg). After his senior season, King earned All-American honorable mention merits and was drafted into the NBA by the Los Angeles Lakers. He spent 10 years playing for LA, San Francisco, Cincinnati and Chicago. King was inducted into TU's Athletic Hall of Fame in 1984 and his #24 jersey was retired on February 24, 2000. (Courtesy of The University of Tulsa.)

Rick Park played for the Golden Hurricane from 1963 to 1965. As a senior, he led TU in scoring with 459 points and an average of 18.4 points per game. Park holds the single-game school record for most free throws made (23) and most free throws attempted (24) with his performance against Arkansas on January 25, 1964. He also maintains the school's single-season record for free throw shooting percentage with .903 (121 of 134) during his junior year, a mark that also led the nation. After being named to the All-MVC team and receiving All-American honorable mention, Park was selected by the Philadelphia 76ers in the 1965 NBA draft. He was inducted into TU's Athletic Hall of Fame in 1990. (Courtesy of The University of Tulsa.)

Julian Hammond played for TU from 1964 to 1966. Hammond was one of four athletes (along with Herman Callands, Sherman Dilliard and Eldridge Webb) to break TU basketball's color barrier. He led the Golden Hurricane in scoring as a senior with 476 points and a 16.4 average. Hammond shot .659 from the field that year to set the school's single-season record. He also led the team in rebounding with 256 boards for an 8.8 average. Hammond was an All-MVC selection and was named an All-American honorable mention. He was drafted by the ABA's Denver Rockets in 1966. (Courtesy of The University of Tulsa.)

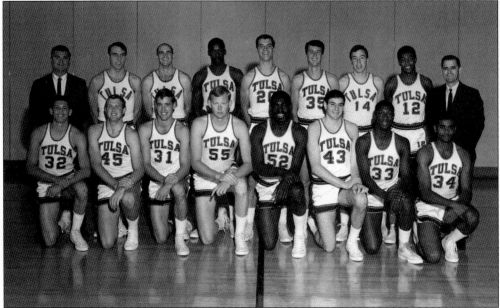

The 1966–67 team recorded a 19-8 mark and earned the school's second ever NIT appearance. The Golden Hurricane finished second in the MVC thanks to a home defeat of St. Louis and series sweeps against Cincinnati, Bradley and Wichita State. TU's season ended with a 64-60 loss against Marquette in New York. Pictured, from left to right, are (front row) Bobby Smith, Bruce Davis, Gary Spess, Tom Bender, Doug Robinson, Dick Potosky, Robert Washington and Warren Smith; (back row) Head Coach Joe Swank, Ralph Watley, Norman Grey, Larry Cheatham, Terry Dunham, Mike Marrs, John McIntosh, Eldridge Webb and Assistant Coach Ken Hayes. (Courtesy of The University of Tulsa.)

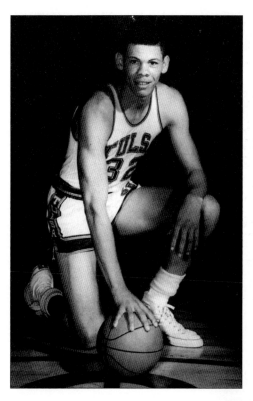

Bobby Smith played for the Golden Hurricane from 1966 to 1969. Smith made an immediate impact as a sophomore by leading TU in rebounding with 282 boards for a 10.4 average. His senior year, he led Tulsa and the MVC in scoring with 661 points for a 24.5 average. Smith was named the MVC Player of the Year and received All-American and All-MVC honors. He finished his career ranked 14th on TU's all-time scoring chart with 1,368 points for a 17.8 average and fifth on TU's all-time rebounding chart with 729 boards for a 9.5 average. Smith was selected by the San Diego Rockets in the 1969 ABA draft. In 1970, he joined the NBA's Cleveland Cavaliers, where he spent 10 seasons. Smith scored 9,513 points for a 13.2 average and collected 3,057 rebounds for a 4.2 average. His #7 jersey is one of just five retired by the Cavaliers. Smith was inducted into TU's Athletic Hall of Fame in 1984. (Courtesy of The University of Tulsa.)

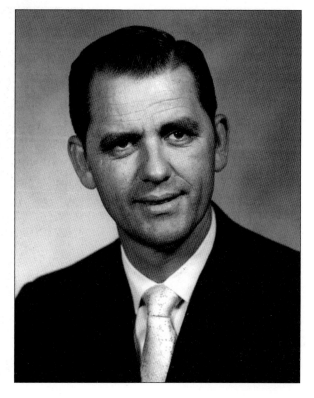

Ken Hayes was TU's head coach from 1968 to 1975. He was elevated to the top position after serving as an assistant coach under Joe Swank. Hayes led Tulsa to seven consecutive winning seasons (the most by any TU coach) and a career record of 117-69. He compiled an 8-11 mark against ranked opponents including the biggest upset in TU history when the Hurricane defeated #3-ranked Louisville during the 1974–75 season. Hayes coached six All-Americans, eight pro draftees and 10 All-MVC selections. He was twice named the MVC Coach of the Year. From TU, Hayes spent the rest of his coaching career at New Mexico State, Oral Roberts and Northeastern State. (Courtesy of The University of Tulsa.)

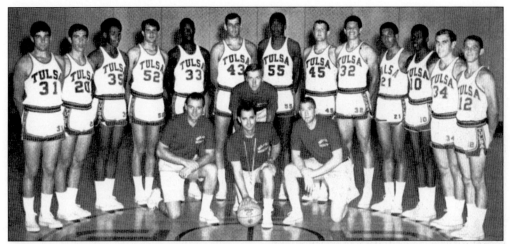

The 1968–69 team went 19-8 in Ken Hayes' first season as head coach and earned a bid to play in the NIT. TU finished third in the MVC with an 11-5 record and was ranked as high as #7 late in the season. The Hurricane registered its most significant upset of the year with a 57-50 victory against #10 Cincinnati. Tulsa also defeated #14-ranked Louisville and #18-ranked Creighton. The team ranks fifth among TU's top scoring units with an 83.1 average. Pictured, from left to right, are (front row) Assistant Coach John Rendik, Head Coach Ken Hayes and Assistant Coach Jerry Evans; (middle row) Assistant Coach Bill Kusleika; (back row) Roger Gray, Ron Carson, Eli Curtis, Joe Hrechko, Rob Washington, Al Cueto, Charles Hall, Bruce Davis, Bobby Smith, Stan Jackson, Larry Cheatham, Ralph Watley and John Herndon. (Courtesy of The University of Tulsa.)

Ron Carson played for TU from 1967 to 1970. As a senior, he led the Golden Hurricane in scoring with 535 points for a 20.5 average. He was also selected to the All-MVC team. Carson was inducted into TU's Athletic Hall of Fame in 1998. (Courtesy of The University of Tulsa.)

Dana Lewis played for Tulsa from 1969 to 1971. He led TU and the MVC in scoring as a junior with 607 points for a 23.3 average. That total ranks 10th among all Golden Hurricane single-season scoring efforts. Lewis also led TU in rebounding both seasons with 309 and 352 boards respectively for averages of 11.9 and 13.5. A two-time All-MVC selection, he earned All-American honorable mention in 1971 and the MVC Newcomer of the Year in 1970. Lewis is ranked 19th on TU's all-time scoring chart with 1,135 points for a 21.8 average and ranked 13th on TU's all-time rebounding chart with 661 boards for a 12.7 average. Lewis left TU after his junior year for the NBA, where he was drafted by the Philadelphia 76ers. (Courtesy of The University of Tulsa.)

Steve Bracey played for Tulsa from 1970 to 1972. As a senior, Bracey was TU's leading scorer with 627 points for a 24.1 average. That point total ranks ninth on Tulsa's single season scoring list. He has four games of 34 points or better, including his 47-point performance against Drake in 1972 that stands third on TU's all-time single game scoring chart. In that game, he also set the school's record for field goals with 21. Bracey is ranked 24th on the school's all-time scoring list with 1,087 points for a 21.3 average. He was named to the All-MVC team and received All-American honorable mention status. Bracey was selected by the Atlanta Hawks in the 1972 NBA draft and later won an NBA Championship with the Golden State Warriors. He was inducted into TU's Athletic Hall of Fame in 2000. (Courtesy of The University of Tulsa.)

Joe Voskuhl played for the Golden Hurricane from 1970 to 1973. He led TU in rebounding as a junior with 261 boards for a 10.4 average and led the Hurricane in rebounding as senior with 284 boards for a 10.9 average. Voskuhl is ranked 14th on Tulsa's all-time rebounding chart with 634 boards for an 8.3 average. His son Jake starred at The University of Connecticut and currently plays in the NBA. (Courtesy of The University of Tulsa.)

Willie Biles played for TU from 1971 to 1974. One of the most prolific scorers in school history, he led TU and the MVC in scoring as both a junior and senior. In 1972–73, Biles set school records with 788 points and a 30.3 average. The following season, he posted TU's sixth-highest single season mark with 641 points. Biles earned All-MVC and All-American honors in both of his final two years at Tulsa. He scored 34 points or better in 15 games and owns seven of TU's top-10 single game performances. Biles scored a school record 48 points twice in his career and scored 40 points or more on eight different occasions. He stands seventh on TU's all-time scoring chart with 1,472 points for a 22.6 average. The Golden State Warriors selected Biles in the 1974 NBA draft. He was inducted into TU's Athletic Hall of Fame in 1994. (Courtesy of The University of Tulsa.)

Sammy High played for TU from 1972 to 1974. Somewhat overshadowed by scoring sensation Willie Biles, High did manage to make his mark by earning All-MVC honors in 1972–73. High was selected by the Kentucky Colonels in the 1974 ABA draft. (Courtesy of The University of Tulsa.)

Tim Carson played for TU from 1971 to 1975 and was the starting point guard as a junior and senior. Towards the end of his junior season, Carson suffered a severe transverse arch sprain against West Texas State, but came back two days later to see action in the inaugural meeting between Tulsa and Oral Roberts. With just seconds left in the game, Carson hit a 30-foot jump shot to lift the injury-riddled Hurricane to an 85-84 victory. (Courtesy of The University of Tulsa.)

Ken "Grasshopper" Smith played for TU from 1973 to 1975. Smith led Tulsa in rebounding as a junior with 215 rebounds (8.3 rpg) and as a senior with 320 rebounds (11.0 rpg). As a senior, Smith led TU and the MVC in scoring with 607 points for a 20.9 average. That point total is ranked 10th on the school's all-time single-season scoring list. In 1974-75, Smith was named All-MVC and All-American honorable mention. He is ranked 23rd on TU's all-time rebounding chart with 535 boards for a 9.8 average. Smith was drafted by the NBA's San Antonio Spurs in 1975. He later played professionally in England and then Belgium, where he played until he was 46 years old and retired a national hero. (Courtesy of The University of Tulsa.)

Jim King returned to his alma mater to serve as TU's head coach from 1975 to the midway point of the 1980 season. During his tenure, Tulsa recorded a 44-82 record including a 3-2 mark against Oklahoma State. In his first season, King's team defeated Oklahoma State, Oklahoma and split its series with Oral Roberts. His best season was in 1978–79 when TU went 13-14 with victories against Manhattan, OSU, Creighton, Wichita State and Bradley. King was relieved of his duties with nine games left in the 1979-80 season. (Courtesy of The University of Tulsa.)

Bill Kusleika served as an assistant coach under his former teammate Jim King. From 1962 to 1964, Kusleika starred on the court for the Golden Hurricane. He led TU in scoring as a junior with 427 points (17.1 per game) and as a senior with 566 points (22.6 per game). Kusleika also paced Tulsa in rebounding as a junior with 217 rebounds (8.7 per game) as a senior with 242 rebounds (9.7 per game). His scoring highs of 42 and 41 points rank seventh and 10th respectively among TU's all-time single-game performances. He was drafted by the Baltimore Bullets in the 1964 NBA draft. Kusleika was inducted into TU's Athletic Hall of Fame in 1987. (Courtesy of The University of Tulsa.)

Bob Okrezesik handles the ball in TU's 87-78 victory against ORU on March 6, 1976. He led the Hurricane with a 12 for 12 performance from the field. Okrezesik played for the Golden Hurricane from 1972 to 1976. (Courtesy of The University of Tulsa.)

Dan O'Leary played for TU from 1973 to 1977. He led TU in rebounding as a junior and senior with 190 boards in both seasons, good for a 7.0 average. O'Leary was named Second Team All-MVC in 1977 and is ranked 23rd on TU's all-time scoring chart with 1,094 points for a 12.0 average. (Courtesy of The University of Tulsa.)

Terry Sims looks for the open man in a game against MVC opponent Drake. The Tulsa, OK, native from Bishop Kelley High School played for the Golden Hurricane from 1975 to 1979. As a junior, he led TU in scoring with 396 points (14.7 ppg) and field goal percentage with .507. As a senior, Sims paced TU in scoring with 357 points (13.7 ppg) and a free throw percentage of .813. (Courtesy of The University of Tulsa.)

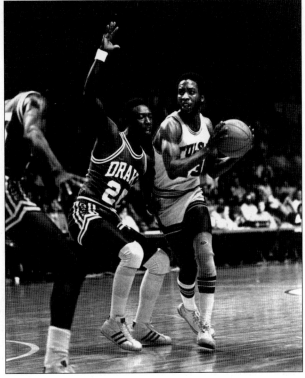

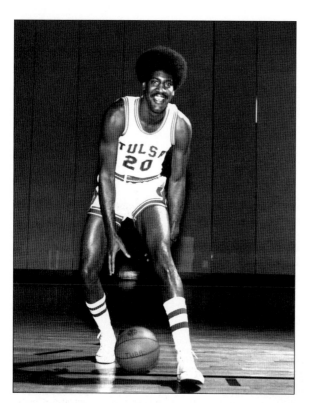

Teko Wynder played for Tulsa during the 1976–77 season. Wynder led TU in scoring with 477 points for a 17.7 average. He also paced the Golden Hurricane with 202 field goals. (Courtesy of The University of Tulsa.)

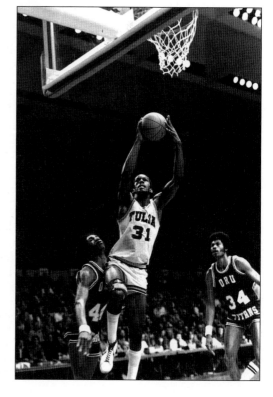

Lester Johnson takes it to the hoop in a game against ORU. Johnson played for TU from 1977 to 1980. He led Tulsa in rebounding as a sophomore with 243 boards and a 9.0 average. Johnson also led the Hurricane in blocked shots as a sophomore (20) and as a senior (26) and paced TU in steals as a sophomore (19). He is ranked 27th on Tulsa's all-time scoring list with 1,036 points for a career 13.5 average. Johnson is also ranked 15th on the all-time rebounding chart with 629 boards for an 8.2 average and 10th on the all-time blocked shots list with 59. (Courtesy of The University of Tulsa.)

FOUR
Rollin' with Nolan
1980–1985

After five straight losing seasons, there was only one thing that could bring a substantial amount of desperately needed cash and resources back into the basketball program—overnight success. Initially, TU boosters were dead set on bringing a young Billy Tubbs to town. He was making waves at Lamar and had an up-tempo style that they hoped would bring excitement back to Tulsa. But Tubbs had attracted the attention of another state school and instead took an offer to coach at Oklahoma.

When Nolan Richardson took the job that Tubbs didn't want, he knew he was TU's plan B. That was fine by the first-year Division I coach. Richardson had already proven he was good. At Western Texas Junior College, he had compiled a 101-14 record over three years. His final season was a 37-0 year that culminated in the national junior college championship. In hindsight, it's easy to see that Richardson was the best fit all along. When he came to Tulsa, he brought with him four players from that Western Texas team, David Brown, Paul Pressey, Phil Spradling and Greg Stewart.

"If TU doesn't make that hire, none of what you're seeing now happens," journalist Jimmie Tramel says. "Billy Tubbs was their first choice but for some reason it didn't work out. No offense to Billy, but Nolan was the better choice because he had that built-in team to bring with him. All it would take is one bad hire in that situation and no one ever gets excited about Tulsa basketball."

To complete his staff, Richardson brought San Diego State assistant Andy Stoglin onboard and retained the interim head coach Bill Franey. Franey resigned his post before the season started and a graduate assistant named Scott Edgar was elevated to full-time assistant. Richardson also snatched up another junior college player named Mike Anderson and won the recruiting battle against Arizona, Arizona State and UCLA for a freshman named Bruce Vanley. The team captain was Bob Stevenson, a senior that had played the previous three seasons under Jim King.

According to Stoglin, there was an underlying feeling that not everyone was happy about Richardson's arrival. Black athletes had only been playing at TU for 16 years and the civil rights movement was less than two decades old. Richardson wasn't looking for acceptance from the opposition but rather sought to defuse it with his winning touch.

"There was a lot riding on us," Stoglin says. "There was a problem with Coach Richardson being the first Black coach in that area and at a historically white school. There were as many people that didn't want us there as there were people who did want us there. We had to come in with a Jackie

Robinson attitude."

Tulsa's fans started to warm up to Richardson early into the season. The team notched comfortable wins against Central State and SW Missouri State. But when the defending national champions invaded the Convention Center, no one was prepared for what was about to happen. Stoglin had scouted #8-ranked Louisville a few days earlier. When he called Richardson from his hotel room, he boldly told the head coach, "They can't beat us." Richardson was confused. With the exception of Darrell Griffith, the Cardinals had returned most of its key players. It was just a few months earlier when they had defeated UCLA for the title.

"Have you been drinking something?" Richardson asked Stoglin. Quite the contrary, his assistant was completely sober and eventually he convinced his boss of that fact. Stoglin knew that Louisville's guards couldn't handle the pressure from Anderson and Pressey. Denny Crum liked to recruit play callers that were bigger than average. This would be a major disadvantage when facing Tulsa's deadly combination of speed and quickness. By the end of the game, Stoglin's prediction had come true and the Hurricane had pulled off the upset 68-60.

"That game made people take us seriously," Stoglin says. "That was the point where things changed. All of the haters jumped off the fence and wanted to become boosters. Some of the people that used to look at us funny, the next day they were hugging us. That was the game that changed it."

Just two days later on December 6, 1980, Tulsa faced a challenge of a completely different nature. Richardson was given the unique opportunity to go head-to-head with the man that was TU's plan A. Beating the defending champs was big, but playing Tubbs and his Oklahoma squad was bigger.

"That was a personal game for him," Stoglin says. "He didn't say it to me, but I could tell by the preparation for that game. He knew that the people wanted Billy Tubbs over him. Even though he never said anything, I know him well and the way we prepared for that game was different. He was so anxious to prove who he was as a basketball coach."

Richardson and Tubbs have been good friends for several years now, but that day in Norman Richardson was Tubbs' worst nightmare as TU upset the hometown favorites 84-75. Two days later, the Hurricane defeated ORU 72-69 at the Mabee Center and later that month beat Oklahoma State 88-86. An impressive 90-76 thumping of Purdue completed an 8-1 non-conference schedule with Richardson's first run through the MVC just over the horizon.

Tulsa finished up its conference season with an 11-5 record and was tied for second place. It was good enough to earn a first round conference tournament game at home. TU squeaked by New Mexico State 68-67 and was rewarded with a semifinal matchup in Des Moines, Iowa against Creighton. This time, the Hurricane failed to win the close one and the Bluejays ended Tulsa's NCAA hopes 66-64. But if losing out on the Big Dance was a ever good thing, this might have been that time.

Even though the team was 21-7 and had upset #8-ranked Louisville and #16-ranked Wichita State, it was still forced to settle for an NIT berth. It was Tulsa's first postseason appearance in 12 years. What favor TU lacked with the NCAA selection committee was made up for by its NIT counterparts. The Hurricane was blessed with three straight games in Tulsa, not at the Convention Center, but rather at the Mabee Center. TU defeated Pan American 81-71 in the first round then dealt a 72-67 loss to UTEP, led by the legendary Don Haskins. In the quarterfinal game, South Alabama nearly crushed TU's title hopes, but fell short as Tulsa prevailed 69-68.

After spending an entire season traveling across college basketball's equivalent of no-man's land, the Hurricane finally got a chance to put its unique product in front of a national audience. That year, the NCAA had just expanded its number of bids to 48, but that still left a lot of great teams for the NIT. Tulsa had already been challenged just to get to this point and it wasn't getting any easier. In the semifinal game, Tulsa endured an 89-87 shootout to defeat an underrated West Virginia team. That set up a championship game against local favorites Syracuse.

Former Notre Dame coach and ESPN broadcaster Digger Phelps told his viewers that TU had no chance to upset the Orangemen. It was a statement that would make Phelps unpopular in Tulsa for years to come. By the end of night, the Hurricane had proven the skeptics wrong, thanks in part

to Greg Stewart's MVP performance. TU's 86-84 victory in overtime made Phelps and his ilk eat their words.

"[Phelps] was supposed to come and apologize to Nolan, but he never did," Stoglin remembers. "He was never really welcome after that because we thought he didn't do the right thing before or after the situation. The NIT made people take Nolan seriously. I remember a lot of coaches had said that our junior college players wouldn't win ten games in Division One."

The NIT championship also breathed new life into Tulsa's sports community. When TU arrived back home, the city had organized a celebratory parade and pep rally. "This all happened in a one season span in a community that wasn't totally ready to accept Nolan Richardson," Edgar says. "And now he's the toast of the town."

Amid the pomp and circumstance, Stoglin says there is one moment from that day that remains etched in his mind.

"Bob Stevenson was the captain and he spoke," Stoglin recalls. "He talked about his years at Tulsa and how they'd lost so many games and he just wanted his senior year to be over. He said that Coach Richardson had come in and given him a senior year that he'd remember for the rest of his life. He had tears in his eyes and Nolan had tears streaming down his eyes. I can't stand to see men cry and I'm sitting there trying to hold my tears back. That was one of the most dramatic moments that I've ever experienced as a coach when I saw this Black coach that nobody wanted and this white player embracing and crying in front of ten thousand people."

When the confetti had settled, TU was able to take pride in its 26-7 record and title as the NCAA's Most Improved Team picking up 18 more wins from the previous season. Richardson won the MVC Coach of the Year Award. Pressey was named First Team All-MVC and MVC Newcomer of the Year. Stewart and Brown were both named Second Team All-MVC. But with a slew of seniors graduating a year later, Tulsa knew it had to hit the recruiting trail hard during the off-season.

TU's NIT success and Richardson's ability to close the deal made for a potent combination. The Hurricane was able to win recruiting battles for Steve Harris and Herbert Johnson. Along the way, Tulsa found a diamond in the rough with its discovery of Vince Williams. Stoglin admits that one of the staff's best recruiting weapons was Richardson's wife Rose. She would cook dinner for the visiting athletes and create a maternal bond with them in a matter of one evening.

"They liked to come over and eat because they knew Nolan couldn't bother them when they were there," Stoglin says.

In the meantime, Richardson's senior class was setting its sight on the NCAA Tournament. The 1981–82 season was nothing more than a mission to obtain that single goal. TU's focus was evident from day one. The Hurricane won 14 of its first 15 with the only blemish at the hands of eventual national champions North Carolina. Victims of that run included Oklahoma State, TCU, Oral Roberts, Oklahoma, Creighton, Drake and #16-ranked Wichita State. Tulsa would go undefeated at home winning all 19 contests and extend its home winning streak to 34.

TU had learned not to leave anything to chance and efficiently took care of business in the MVC Tournament. Three straight wins at the Convention Center and the NCAA Tournament bid was a lock. The Hurricane dominated much of the season despite playing several games without Brown who injured his knee twice and saw limited time on the court.

Not only did TU earn the NCAA bid, it was given the chance to stay at home for the first round. The Hurricane was slated to play Houston at the Mabee Center. What most people didn't realize was the Cougars were about to explode onto the national scene. Players like Akeem Olajuwon and Clyde Drexler made up the nucleus of the phenomenon that would soon be known as Phi Slamma Jamma. Still, Richardson was confident that in a man-to-man situation, the Hurricane could prevail. Unfortunately, TU was facing a savvy coach that had done his homework.

"Guy Lewis did a really good job of spreading our defense," Stoglin says. "He went to a 2-1-2 offense. Our press was so good and I remember he spread us out. If he had not done that, they couldn't have beaten us, even with all of those great athletes they had."

Houston won the game 78-74 and went on to reach the Final Four. TU's season was done and

the highly-touted senior class had reached the end of its collective career. Tulsa finished 24-6 on the year and again received numerous individual honors. Steve Harris was named MVC Newcomer of the Year and Greg Stewart was tabbed Second Team All-MVC. Paul Pressey became one of the school's most decorated players. He was the MVC Player of the Year and First Team All-MVC. Pressey was named Second Team All-American by UPI, the NABC and the USBWA. The Associated Press named him a Third Team All-American.

And while most people credited the junior college transfers for all of the team's success those two years, Stoglin says it was really Richardson's system that deserves the recognition. "His system is unique," he says. "It puts pressure on people and it's hard to prepare for. He trusts his players to make decisions. He let's them trap and gives them freedom."

In 1982–83, Tulsa took a slight downward turn but still produced a high level of play on the court. The Hurricane beat Oklahoma for the third straight year but had its 36-game home winning streak at the Convention Center broken when Oklahoma State won 93-75 on December 7, 1982. TU also lost back-to-back games at the Cabrillo Classic in San Diego, CA, losing to #16-ranked Villanova and Florida State.

"That was a brand new team," Edgar says. "Anytime you have to rebuild, you don't have automatic success. That team did very well and those kids that came in continued to carry the tradition that the Paul Pressey and Mike Anderson group had set forth. It was an inexperienced team that was competing in a league that should have had more NCAA bids."

TU's brightest moment of the season came at the Oil Capital Classic held at the Mabee Center. In the first round, Tulsa faced defending champions #17-ranked North Carolina. The Tar Heels were loaded with talent including Sam Perkins, Matt Doherty, future TU head coach Buzz Peterson and a young sophomore named Michael Jordan. The game went back and forth until Tulsa pulled away in the second half with a near-perfect 19 of 21 shooting performance from the field. The Hurricane won 84-74 and was led by Bruce Vanley who would later be named tournament MVP.

"That was a game where (Richardson) was able to take little known Tulsa and beat a national powerhouse," Edgar says. "Bruce Vanley just totally dominated Sam Perkins."

Tulsa defeated ORU 63-56 in the tournament final and later crushed its cross-town rival 101-70 in a return visit to the Mabee Center. The MVC season, however, turned out to be Richardson's least successful. Tulsa finished tied for third with an 11-7 record and had a difficult road ahead in order to win the conference tournament. The Hurricane handily defeated Indiana State 108-84 in first round action at home. TU was then sent to Las Cruces, NM, where the team scored the lowest point total of Richardson's career but still snuck away with the 49-48 win.

In just two days, Tulsa was slated to play Illinois State in Normal, IL, for the tournament final. For the Hurricane, it was the third game in five days in three different locations. The team's travel-weary legs were heavy and the Redbirds took full advantage and knocked Tulsa out of NCAA contention with a commanding 84-64 win.

TU was again invited to play in the NIT and, surprisingly,again was given the right to play at the Mabee Center, the same place where the magical run of 1981 had been launched. But this time, there was not to be a repeat trip to New York. TCU's 64-62 victory ended the Hurricane's season at 19-12. In the rebuilding phase, sophomore Steve Harris continued to amaze people with his flawless shooting touch. He was named First Team All-MVC and received Honorable Mention All-American kudos. Junior college transfer Ricky Ross made an immediate impact and earned Second Team All-MVC accolades.

According to Edgar, 1983–84 was "a season of unknowns." Bruce Vanley was the only player left from Richardson's first team and he, along with Harris and Ross, would be expected to carry the load. TU did dig into Texas for some quality recruits that year such as David Moss and Brian Rahilly. A relatively uneventful non-conference schedule allowed TU to reel off 10 straight victories to start the season with highlights coming against ORU and Oklahoma State.

By the time conference play began, the Hurricane was hitting its stride. TU went 13-3 in the MVC and finished in a tie for first place. Tulsa defeated Indiana State and Wichita State rather easily in the first two games of the tournament, but faced a tough challenge in a Creighton team

that was led by future NBA star Benoit Benjamin. TU had swept the season series, including an 82-80 overtime nailbiter at Omaha. The MVC title game was no different and it took a buzzer beater from Ricky Ross to give TU the 70-68 win and second NCAA berth in three years.

Tulsa took its #12 national ranking to Milwaukee, Wisconsin, for a meeting with Louisville. Tulsa trailed early in the game, but Ross and Harris took over towards the end and brought the Hurricane all the way back. With time running out, the score was tied 67-67 and Louisville had the ball. Edgar recalls Milt Wagner dribbling the ball in the corner, looking for the open shot. When he finally released the ball, it found its mark and Tulsa had come up short 69-67.

"Milt Wagner hit the game winning shot from the corner after shuffling his feet several times," Edgar says. "I got to be friends with him a few years later and he always talked about that shot but then I told him, 'You should have made the shot. You walked all the way until you got open.'"

By season's end, Tulsa had recorded Richardson's best mark, finishing 27-4. The team led the nation in scoring average with 90.8 points per game (also a school record) and had eight games with 100 points or more. Harris averaged 21.1 points per game to pace the Hurricane. He and Ross were both named First Team All-MVC and Honorable Mention All-American.

As the 1984–85 season approached, memories of the NIT championship team had faded. Now, a new group of players was making its mark on the program. While Harris was embarking on his senior year, a heavily-recruited Oklahoma City athlete named Tracy Moore was just starting his journey as a member of the Golden Hurricane. Moore's arrival was yet another testament to Richardson's ability to hang with the big boys.

A year earlier, Tulsa didn't have Oklahoma on its schedule. That decision was made by the Sooners, who had lost the three previous contests. Tubbs brought his #8-ranked team to the Convention Center fully confident that Wayman Tisdale and company could finally get the job done. Tubbs was already famous for his high-scoring, fast-paced offensive style and that was exactly what he got. But this time, the team that broke into triple digits was the Hurricane as Tulsa ran away with the 104-89 upset.

After the game, Tubbs vowed to never come back to Tulsa. He was faithful to that promise for as long as he coached at Oklahoma. Unfortunately, the now-legendary coach was forced to return to the scene of the crime in 1997 when his TCU squad was scheduled to play a Western Athletic Conference game against TU.

Tulsa finished the regular season winning its first outright MVC title under Richardson. TU again had the chance to run the table at home and claim another tournament title. The #15-ranked Hurricane won competitive games against West Texas State and Bradley, but was upset by Wichita State 84-82 in the championship game. For the first time, TU was awarded an at-large bid to the NCAA Tournament. The team would be matched up with UTEP in Albuquerque, NM

As Richardson was preparing for the game, he received a distressing call from his wife, Rose. "She was in tears," Edgar recalls. "She had just been to the doctor's office with Yvonne and said the doctor thought she had cancer."

Richardson was devastated by the horrific news of his 13-year old daughter's condition. Doing his best to balance the needs of his family with the needs of his team, Richardson stayed behind when Tulsa traveled to the first round tournament site. Edgar and Rob Spivery took over until the head coach's arrival on the day of the game. It was a tough rematch from the two team's earlier meeting in the 1981 NIT, but this time the Miners would prevail with a 79-75 victory.

The Hurricane finished with a 23-8 record and Richardson was named MVC Coach of the Year for the second time in his career. Steve Harris ended his career as the school's leading scorer (he would later be surpassed by Shea Seals) and averaged 23.6 points in his final year. Harris was also named First Team All-MVC and First Team All-American. Herb Johnson was named Second Team All-MVC and went on to a lengthy professional career in Europe that was still ongoing in 2004.

In the midst of his family crisis, Richardson was offered the head job at Arkansas. Not wanting to move his ailing daughter to another home, he weighed the options heavily and seriously considered staying at TU. In the end, it was Yvonne who encouraged her father to make the move.

In 1987, the brave young fighter lost her two-year battle with cancer.

After five years at Tulsa, the Richardson era was over, but not before stretching the Hurricane hoops program to unprecedented levels of success. He finished his career with the second most wins (137) and best winning percentage (.763) among all TU coaches. Richardson compiled a stellar 21-1 record against state schools (4-0 vs. Oklahoma, 10-0 vs. ORU, 4-1 vs. OSU, etc.) and dramatically increased the level of talent to put on the Tulsa uniform. That included eight NBA draft picks, two All-Americans and three Honorable Mention All-Americans. The end result was nothing less than a miraculous revival of excitement and enthusiasm.

"It was a great time to be in Tulsa," Edgar says. "They've had other great coaches there. They've had fan support. But I don't think you can compare any other era to the Nolan Richardson era. The level of excitement was probably unparalleled. When we played at the Convention Center, it wasn't just a game, it was an event."

No doubt, when Nolan left the building, he left a cavernous hole that some unfortunate soul was going to be asked to fill.

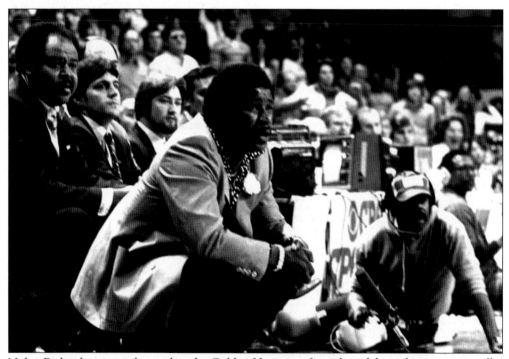

Nolan Richardson intently watches the Golden Hurricane from the sidelines during a nationally-televised game. Richardson coached TU from 1980 to 1985 and recorded a 119-37 mark. His .763 winning percentage is the best among all TU coaches. In his first season at the helm, Richardson led Tulsa to its most dramatic single-season turnaround with 18 more wins than the previous season. That squad went 26-7 and claimed the NIT Championship. He was the first TU coach to record 50 wins in his first two seasons. Richardson's team set a school record in 1981–82 with a 19-0 home mark. Richardson coached five All-Americans and 11 All-MVC performers. He was twice named MVC Coach of the Year (1980–81 and 1984–85). He is the only Tulsa coach to post a winning record against ranked opponents (6-3) and on February 16, 1982, he helped TU earn its highest national ranking at the #6 position. Richardson left Tulsa in 1985 for the head job at Arkansas where he led the Razorbacks to three Final Four appearances, two championship games and the NCAA title in 1994. (Courtesy of The University of Tulsa.)

Scotty Edgar served as an assistant coach under Nolan Richardson from 1980 to 1985. He followed Richardson to Arkansas where he stayed for six years before taking the head coaching job at Murray State. He led the Racers to a 79-40 record and two NCAA appearances. Edgar spent three years as the head coach at Duquesne and was an assistant coach at TCU before joining Mike Anderson's staff at Alabama-Birmingham. (Courtesy of The University of Tulsa.)

Andy Stoglin served as an assistant coach under Nolan Richardson from 1980 to 1982. He took the head coaching job at Southern before working as an assistant at Oklahoma State for one year. He rejoined Richardson in 1985 for another three years. Stoglin eventually moved on to take the top job at Jackson State where he stayed for 14 years. He has also coached professionally overseas in Qatar and stateside in the USBL and ABA. (Courtesy of The University of Tulsa.)

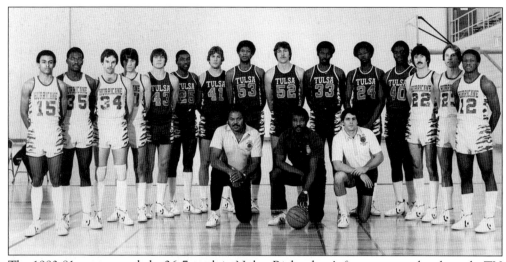

The 1980-81 team recorded a 26-7 mark in Nolan Richardson's first season as head coach. TU was the most improved team in the nation, winning 18 more games than the year before. It stands as the seventh best turnaround in NCAA Division I history. The Golden Hurricane upset defending national champions #8-ranked Louisville and went 4-0 against the state schools. Tulsa finished tied for second in the MVC and lost to Creighton in the second round of the MVC Tournament. TU earned a bid to the NIT, winning five straight games and its first NIT championship trophy. Pictured, from left to right, are (front row) Assistant Coach Andy Stoglin, Head Coach Nolan Richardson and Assistant Coach Scott Edgar; (back row) Johnny Craven, Rondie Turner, Jim Lacey, Brad Laraba, Bob Stevenson, Paul Pressey, Jeff Kovach, Bruce Vanley, Ed Lindblad, Greg Stewart, David Brown, Steve Ballard, Phil Spradling, Ty Nilsson and Mike Anderson. (Courtesy of The University of Tulsa.)

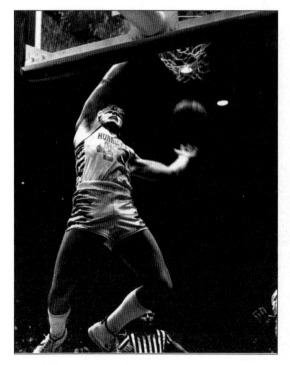

Bob Stevenson puts the finishing touches on a move that was affectionately known as "the snake dunk." Stevenson played for TU from 1977 to 1981. As a junior, he led Tulsa with 265 rebounds for a 9.8 average and paced the Hurricane with 44 steals. Stevenson was named Second-Team All-MVC. He is ranked 21st on the school's all-time rebounding chart with 565 for a 5.1 average. (Courtesy of The University of Tulsa.)

Paul Pressey launches a long distance jump shot. Dubbed "the Rubberband Man," Pressey starred for the Golden Hurricane from 1980 to 1982. As a senior, he led Tulsa in scoring with 395 points (13.2 average) and rebounding with 192 boards (6.4 average). As a junior, Pressey paced TU with 172 assists (5.2 average) and 26 blocked shots. In both seasons, he topped all Hurricane defenders with a combined 191 steals and in 1980-81, he led the nation with 96 swipes. Pressey set the school's single-game steals mark with eight and ranks fourth on the all-time career steals chart with 191. He also stands 12th on the all-time assists list with 291 and 14th on the all-time blocked shots chart with 46. Pressey was named MVC Newcomer of the Year (1980–81) and MVC and District V Player of the Year (1981–82). He was also named Second Team and Third Team All-American following his senior season. Pressey was selected by the Milwaukee Bucks as the 20th overall pick in the 1982 NBA Draft. He also spent time with Golden State and San Antonio and went on to a career as an assistant coach with several NBA teams. Pressey's #25 jersey is retired and he was inducted into TU's Athletic Hall of Fame in 1993. (Courtesy of The University of Tulsa.)

David Brown drives to the basket in Tulsa's 68-60 upset victory over #8-ranked Louisville at the Convention Center on December 4, 1980. Brown played for TU from 1980 to 1982. As a junior, he was the co-leader in rebounding with 227 boards for a 6.9 average. Brown was also named second team All-MVC that year. (Courtesy of The University of Tulsa.)

Mike Anderson drives past a pair of Louisville defenders for the layup. Anderson played for TU from 1980 to 1982. As a senior, he led Tulsa with 133 assists for a 4.4 average. Anderson ranks 17th on TU's all-time assists chart with 250 and ninth on TU's all-time steals leader with 140. He returned in 1983 to serve as a volunteer assistant under Nolan Richardson and followed his former coach to Arkansas. After spending 14 years with the Razorbacks, Anderson took the head coaching job at Alabama-Birmingham where he led the Blazers to the 2004 NCAA Tournament's Sweet 16. (Courtesy of The University of Tulsa.)

Phil Spradling pushes the ball down the court during a TU fast break. Spradling played for Tulsa from 1980 to 1982. Although he was statistically overshadowed by many of his teammates, Spradling played an important role on TU's NIT Championship team in 1980–81. (Courtesy of The University of Tulsa.)

Greg Stewart scores two for Tulsa on a reverse dunk. Stewart played for TU from 1980 to 1982. He led the Golden Hurricane in scoring as a junior with 513 points for a 15.5 average. Stewart was the co-leader in rebounding as a junior with 227 boards (6.9 rpg) and as a senior with 191 boards (6.4 rpg). He was also a two-time Second-Team All-MVC selection. Stewart ranks 17th in blocked shots with 43 and was drafted by Boston Celtics in the fourth round of the 1982 NBA draft. (Courtesy of The University of Tulsa.)

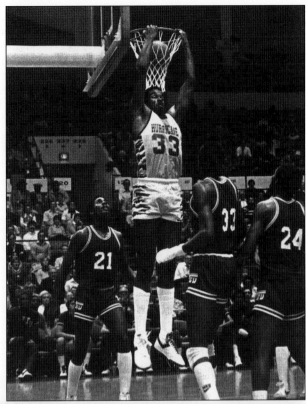

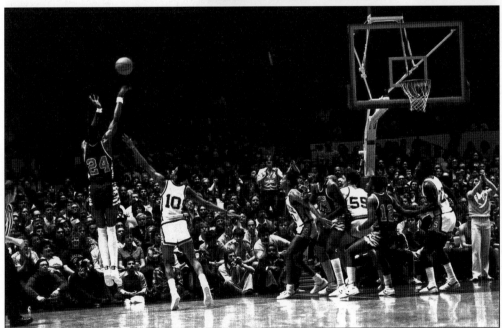

David Brown takes a jump shot from the left wing in the NIT Championship game on March 25, 1981, at Madison Square Garden in New York City. The Golden Hurricane defeated Syracuse 86-84 in overtime to claim the school's first NIT title. (Courtesy of The University of Tulsa).

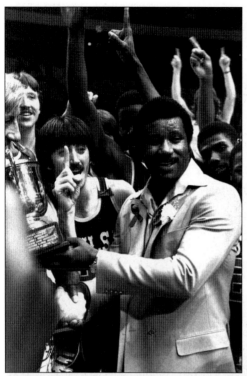

Nolan Richardson hoists the NIT Championship trophy as his players gather around to celebrate. TU played its first three games at the Mabee Center where the team defeated Pan American (81-71), UTEP (72-67) and South Alabama (69-68) before traveling to New York City for tournament victories against West Virginia (89-87) and Syracuse (86-84 in overtime). (Courtesy of The University of Tulsa).

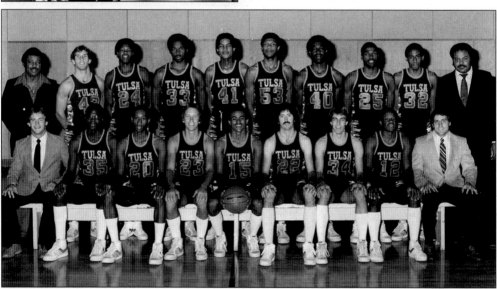

The 1981–82 Golden Hurricane squad went 24-6 and earned an automatic NCAA bid by winning the MVC Tournament. The team recorded the school's best home mark, going 19-0 and boasted the MVC Player of the Year (Paul Pressey) and MVC Newcomer of the Year (Steve Harris). Pictured, from left to right, are (front row) Manager Bill Melton, Rondie Turner, Steve Harris, Ty Nilsson, Johnny Craven, Phil Spradling, David Lampton, Mike Anderson and Assistant Coach Scott Edgar; (back row) Head Coach Nolan Richardson, Chuck North, David Brown, Greg Stewart, Herb Johnson, Bruce Vanley, Steve Ballard, Paul Pressey, Vince Williams and Assistant Coach Andy Stoglin. (Courtesy of The University of Tulsa.)

Ricky Ross takes it to the glass against Wayman Tisdale in TU's 79-76 victory at #20-ranked Oklahoma on December 4, 1982. Ross played for the Golden Hurricane from 1982 to 1984. As a junior, he led TU in scoring (575 points for an 18.5 average) and rebounding (173 rebounds for a 5.6 average) en route to a Second-Team All-MVC selection. As a senior, he led TU in assists with 191 for a 6.2 average and was named First-Team All-MVC and Honorable Mention All-American. On March 1, 1984, Ross set a single-game school record with 15 assists against Indiana State. He was selected by the Washington Bullets in the third round of the 1984 NBA draft. Ross ranks 22nd on TU's all-time scoring chart (1,111 points for a 17.9 average) and 13th on TU's all-time assist chart with 285. (Courtesy of The University of Tulsa.)

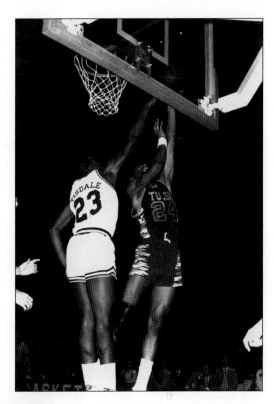

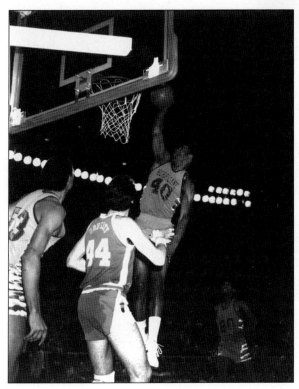

Steve Ballard dunks the ball over North Carolina's Matt Doherty as teammates Bruce Vanley (#53) and Steve Harris (#20) look on. Tulsa defeated the #17-ranked Tar Heels 84-74 at the Mabee Center on December 17, 1982. Ballard played for TU from 1980 to 1983. As a senior, he led Tulsa in field goal shooting by hitting 93 of 149 attempts for a .617 percentage. (Courtesy of The University of Tulsa.)

63

The 1983–84 team went 27-4 and earned an automatic NCAA Tournament bid by winning the MVC Tournament. The squad posted a modern era record of 15 consecutive wins and led the nation in scoring with 2,816 points for an average of 90.8 points per game. That mark also set the school record. Pictured, from left to right, are (front row) Head Coach Nolan Richardson, Steve Harris, Brian Rahilly, Herb Suggs and Carlton McKinney; (middle row) Assistant Coach Rob Spivery, Byron Boudreaux, Assistant Coach Scott Edgar, Rondie Turner and David Moss; (back row) Warren Shepherd, Manager Jay Wagnon, Jeff Rahilly, Herb Johnson, Steve Kennedy, Bruce Vanley, Assistant Coach Al Grushkin, Vince Williams, Manager Brent Keys and Anthony Fobbs. (Courtesy of The University of Tulsa.)

Bruce Vanley battles through a hard foul against MVC opponent Creighton. Vanley played for Tulsa from 1980 to 1984. He led TU in field goal percentage as a sophomore (.608) and a senior (.603). Vanley also paced the Golden Hurricane in blocked shots as a sophomore and a junior with 24 in both seasons. He ranks fourth on TU's all-time blocked shot chart with 93. Vanley ranks 22nd on the school's all-time rebounding chart with 549 boards and 25th on the all-time scoring chart with 1,083 points. He was selected by the Kansas City Kings in the sixth round of the 1984 draft. (Courtesy of The University of Tulsa.)

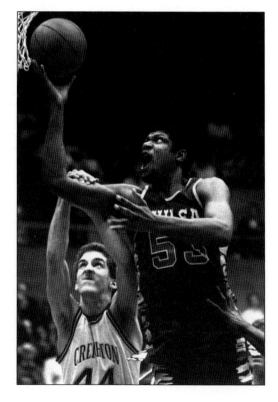

The 1984–85 team went 23-8, won the MVC regular season title and earned an at-large bid to the NCAA Tournament. The Hurricane defeated #8-ranked Oklahoma and Oklahoma State and took both games in the series with Oral Roberts. Tulsa ended its season with a first-round NCAA tournament loss to UTEP and a #18 national ranking. The team ranks eighth in school history with an 81.5 scoring average. Pictured, from left to right, are (sitting front) Tracy Moore, Byron Boudreaux and Herb Suggs; (sitting back) David Otto, Manager Brent Keys, Daryl Deckard, Chuck Celestine, Manager Jay Wagnon and Assistant Coach Al Grushkin; (standing) Head Coach Nolan Richardson, Assistant Coach Scott Edgar, Steve Harris, Carlton McKinney, Anthony Hurd, Brian Rahilly, David Moss, Assistant Coach Rob Spivery, Clifford Langford, Herb Johnson, Anthony Fobbs, Jeff Rahilly and Vince Williams. (Courtesy of The University of Tulsa.)

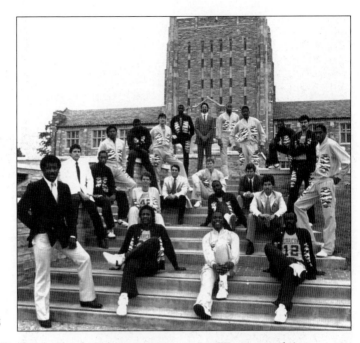

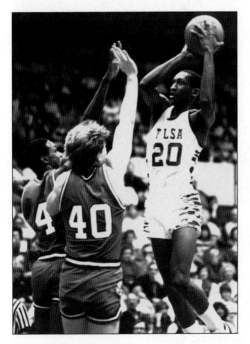

Steve Harris prepares to loft a shot over two defenders. Harris played for TU from 1981 to 1985. Nicknamed "Silk" for his smooth shooting style, he led Tulsa in scoring as a senior with 732 points for a 23.6 average. Harris holds school career records with 904 field goals and 460 free throws. He ranks second on the all-time scoring chart (2,272 points) and steals chart (271) and ranks 18th on the all-time assists chart (243). His 18.6 career average is the highest among all four-year letterwinners. Harris shares the school's single-game steals mark with eight against Pepperdine during the 1983–84 season. He was selected as the MVC Newcomer of the Year in 1981–82 and was named First Team All-MVC in each of his last three years. As a senior, Harris was named First Team All-American by UPI and Third Team All-American by Basketball Times. He was also named Honorable Mention All-American as a sophomore and junior. Harris was picked 19th overall by the Houston Rockets in the first round of the 1985 NBA draft. His #20 jersey has been retired and he was named to TU's Athletic Hall of Fame in 1995. (Courtesy of The University of Tulsa.)

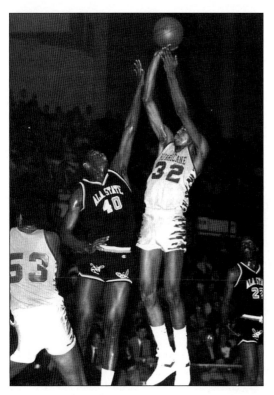

Vince Williams takes a shot over his defender in TU's 79-72 victory against Alabama State on December 3, 1983. Williams played for Tulsa from 1981 to 1985. As a junior, he led TU in blocked shots with 30 and is ranked eighth in school history with 64. Williams unwittingly played his entire career with a faulty heart. Originally thought to have asthma due to his chronic breathing problems, it was discovered he needed a transplant. He received that new heart but 10 years later encountered more problems. Sadly, Williams passed away in September of 2002. (Courtesy of The University of Tulsa.)

Herb Johnson eyes a baseline jumper against MVC foe Drake. Johnson played for the Golden Hurricane from 1981 to 1985. As a junior, he led TU with 236 rebounds for a 7.6 average. As a senior, the Second-Team All-MVC selection paced Tulsa with 293 rebounds (9.5 rpg), 90 assists and 15 blocked shots. Johnson ranks 13th on TU's all-time scoring chart (1,372 points for an 11.2 average), fourth on TU's all-time rebounding chart (764 points for a 6.2 average), eighth on TU's all-time steals chart (143) and 13th on TU's all-time blocked shot chart (51). He was selected by the Cleveland Cavaliers in the third round of the 1985 NBA draft. Johnson went on to play professionally in Europe for two decades, most recently in Switzerland during the 2004 season. (Courtesy of The University of Tulsa.)

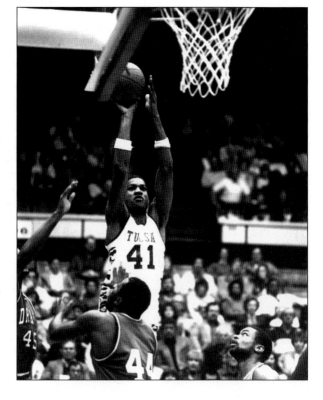

FIVE
Barnett's Battle
1985–1991

Following in the footsteps of the man who rescued, revived and revolutionized TU basketball wasn't going to be an easy job. Somebody had to do it and on paper, J.D. Barnett seemed like a pretty strong candidate to take over for the recently departed Nolan Richardson. Barnett had led Virginia Commonwealth to six consecutive winning seasons and five NCAA Tournament appearances.

"There was no question that [J.D.] was one of the better 'X's and O's' coaches around," says journalist Ken MacLeod. "His man-to-man defensive principles and the things he could get accomplished defensively were legendary."

In Barnett's first season, he had a weapons cabinet that had been left fully stocked and loaded. Nine players from the previous NCAA Tournament team were at his disposal. Barnett masterfully melded his defensive schemes with the deep talent pool and created a unit that would hold teams to an average of 57.9 points per game. The Hurricane defeated Oklahoma State, Arizona, Dayton and Colorado and swept a two-game series with Oral Roberts.

TU finished tied for second place in the MVC. The MVC Tournament was again held at the Convention Center and Tulsa took full advantage with wins against Indiana State, Drake and a major upset of #9-ranked Bradley. The NCAA Tournament provided a much more difficult challenge when TU was matched up against #17-ranked Navy, led by David Robinson. The Midshipmen prevailed 87-68 ending the Hurricane's season with a 23-9 record.

Barnett's formula was again successful in 1986-87 with non-conference victories against Oklahoma State, Providence, Xavier, Mississippi and Baylor. Tulsa bested its MVC performance by winning the regular season title. The obvious favorites to win the tournament on its home court, TU stumbled in the semifinals with an overtime loss to Wichita State. But an at-large NCAA Tournament bid was still in order. Again, the Hurricane would drop its first round game, this time to in-state rival Oklahoma 74-69. Having proven his first season's success wasn't a fluke, Barnett was rewarded with the MVC Coach of the Year award.

The 1987–88 season provided Barnett with his toughest test. Gone were the players recruited by Nolan Richardson and his staff. David Moss, Byron Boudreaux and the Rahilly brothers exited stage left and Tracy Moore was the sole holdover. TU opened with a 68-47 victory against Arkansas. It was Richardson's first return to the Convention Center since leaving to coach the Razorbacks three years earlier.

The rest of the season contained few bright spots as the team struggled to put away close games. Tulsa lost eight games by five points or less and lost all five of its overtime contests (including four in double OT). The Hurricane finished 8-20 and plummeted to a last place conference finish. Moore carried the team on his shoulders, scoring 21.3 points per game and earning First Team All-MVC honors.

To Barnett's credit, he didn't allow Tulsa to stay down for long. With a roster completely filled by his own recruits, he bounced back in 1988–89 for a respectable 18-13 season. A tough non-conference schedule was tempered by a 10-4 MVC performance that resulted in a tie for second place. At the MVC Tournament, Tulsa lost to Southern Illinois 73-66 and fell short of an NIT berth by one or two wins. Lamont Randolph and Ray Wingard earned Second Team All-MVC accolades and Michael Scott was named MVC Defensive Player of the Year.

As the 1989–90 season approached, fans were intrigued by the arrival of two junior college transfers. Marcell Gordon hailed from San Francisco, CA, and Reggie Shields called Orlando, FL, his hometown. The two guards led Tulsa to a second-place tie in the MVC and Shields was named MVC Newcomer of the Year. Gordon's intense style of play made him an instant fan favorite.

"Marcell Gordon was a hoot," MacLeod says. "That guy played hard. He ran into me after practice one day. He flattened me against the wall. He didn't mean to. He was just chasing a loose ball and I happened to be walking by. That gave me an idea of how hard these guys play."

TU's season was marred by inconsistent play, but there were enough high points to salvage a postseason berth. The Hurricane's upset of #22-ranked Oklahoma State set up a rematch in the NIT. But the second time around, OSU prevailed 83-74 in Stillwater and TU ended its season with a 17-13 record. Senior Lamont Randolph earned Second Team All-MVC honors and a freshman from Saginaw, MI, named Lou Dawkins emerged as a player to watch.

In 1990, a freshman from Fort Worth, Texas made a big decision that greatly impacted TU's future. Gary Collier wanted to play for Oklahoma State, but at the time, head coach Leonard Hamilton was preparing to take the Miami job. Instead, he chose Tulsa, where he felt he could shine in the MVC. His prep coach was the legendary Robert Hughes, a TU graduate from Sapulpa, OK, who put Dunbar High School on the national map. Collier had little trouble adjusting to Barnett's aggressive coaching style.

"He was hard nosed," Collier says. "He would push you. But I wasn't a stranger to hard work and I understood that the yelling was just a way to motivate his players. I was already accustomed to it."

Collier saw limited action that season playing in 26 of 30 games for less than 10 minutes per contest. He watched from the sidelines as his teammate Dawkins was forced to redshirt after injuring his knee in a 75-73 loss to Oklahoma State. Tulsa finished third in the MVC and traveled to St. Louis for the postseason tournament. After defeating Wichita State in the first round, TU lost a double overtime game to first-year conference mates SW Missouri State (82-80).

Tulsa was given the opportunity to play in the NIT with a rematch against Oklahoma. The Sooners had defeated TU 112-99 in the championship game of the All-College Tournament earlier that season. OU prevailed 111-86 and Tulsa's season ended with an 18-12 record. Marcell Gordon was named First Team All-MVC and Michael Scott claimed his second MVC Defensive Player of the Year award in three years.

After six seasons, Barnett had crafted a 106-75 mark and four postseason tournament appearances. His win total ranks fourth among all TU coaches. But the university was growing wary of his unpredictable temperament and a growing contingency of fans was longing for the program's days of national prominence that had been ushered in by Richardson. On March 20, 1991, Barnett was fired.

"J.D.'s problems were all self-inflicted," MacLeod says. "He would've been okay if he would have been a little more personable and a little less inclined to dig his own grave with the sideline antics and the yelling at his players."

Collier says the players were genuinely surprised to hear that Barnett had been relieved of his post. He now had a serious decision to make.

"I thought it was just a rumor," Collier recalls. "I didn't think there was any truth to it. To have him out of there, I had mixed emotions. He was the coach that recruited me and I knew him. But there was another side of me that thought maybe I could get a clean slate with a new coach. I didn't know what I was going to do at that time. I was even thinking about transferring. I talked to my mother and my brother and they told me to give the new coach a chance."

TU's basketball program was at a crossroads. Just like the decision that faced athletic administrators in 1980, the next head coaching hire could either make or break the long-term future of Hurricane hoops. Athletic Director Rick Dickson promptly went on a gold-mining expedition in some familiar places, but it wasn't until he veered off course when he finally uncovered a gem.

J.D. Barnett served as Tulsa's head coach from 1985 to 1991 after leaving the top job at Virginia Commonwealth. He became the first TU coach to reach the NCAA Tournament in his first season. In six seasons, Barnett compiled a 106-75 record and led the Hurricane to a pair of NCAA Tournament appearances and two invitations to the NIT. He was named MVC Coach of the Year in 1987 after leading TU to a 22-8 record and first-place conference finish. Barnett coached 10 All-MVC performers and seven MVC All-Academic honorees. His biggest victory came when Tulsa defeated #9-ranked Bradley 74-58, March 5, 1986 at the Convention Center. After the 1990–91 season, Barnett was relieved of his duties and went on to take the head job at Northwestern Louisiana. He later moved on to work in athletic administration at Tulane. (Courtesy of The University of Tulsa.)

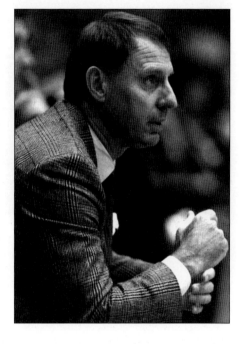

Flip Saunders was an assistant coach under J.D. Barnett from 1986 to 1988. He spent the next seven years as a head coach in the CBA before assuming the head job with the NBA's Minnesota Timberwolves in 1995. Saunders led Kevin Garnett and the Timberwolves to the 2004 NBA Western Conference Finals. (Courtesy of The University of Tulsa.)

Kevin O'Neill was an assistant coach under J.D. Barnett during the 1985–86 season. After three years as an assistant at Arizona State, O'Neill took head coaching jobs at Marquette, Tennessee and Northwestern. He spent another three years as an NBA assistant before being named Toronto's head coach for the 2003–04 season. (Courtesy of The University of Tulsa.)

Tom Izzo came to Tulsa in May of 1986 to work as J.D. Barnett's top assistant. He only stayed until June 10th when he returned to Michigan State to take a vacant assistant coaching job with the Spartans. Izzo eventually took over the head job at MSU where he won an NCAA Championship and has been named National Coach of the Year three times. (Courtesy of The University of Tulsa.)

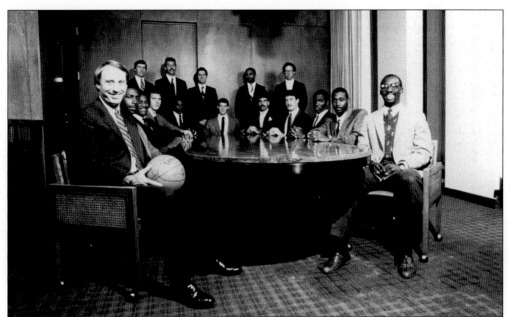

The 1985–86 team recorded a 23-9 mark and earned an automatic NCAA bid by winning the MVC Tournament. Tulsa recorded key victories against Oklahoma State, Arizona and a pair of wins over Oral Roberts. The Hurricane's season ended with a first round NCAA loss against a Navy team led by David Robinson. Pictured, from left to right, are (sitting) Head Coach J.D. Barnett, Chuck Celestine, Tracy Moore, David Otto, Anthony Fobbs, Daryl Deckard, Jeff Rahilly, Brian Rahilly, Byron Boudreaux, David Moss and Herb Suggs; (standing) Assistant Coach Jim Rosborough, Graduate Assistant Coach Ron Jirsa, Volunteer Assistant John Mackey, Assistant Coach Tony Branch and Assistant Coach Kevin O'Neill. (Courtesy of The University of Tulsa.)

Jeff Rahilly played for Tulsa from 1982 to 1987. He played a vital supporting role on three NCAA Tournament teams and one NIT team. After a medical redshirt year in 1983–84, he returned to share the court with his younger brother Brian for three seasons. (Courtesy of The University of Tulsa.)

The 1986–87 team went 22-8 and claimed the MVC regular season title. Some of TU's key victories included wins against Xavier, Oklahoma State, Mississippi and USC. The Hurricane earned an at-large bid to the NCAA Tournament and lost to Oklahoma in the first round 74-69. For his efforts, J.D. Barnett was named MVC Coach of the Year. Pictured above, from left to right, are (sitting) Rodney Johnson, Tracy Moore, John Buckwalter, Byron Boudreaux and Rod Parker; (standing) Jeff Rahilly, Brian Rahilly, David Moss, Don Royster and Brian Loyd. (Courtesy of The University of Tulsa.)

Brian Rahilly played for TU from 1983 to 1987. He is one of just six players to play in four NCAA Tournaments. Rahilly led Tulsa in rebounding as a senior with 218 boards (7.3) average and was named Second Team All-MVC. He was selected by the Philadelphia 76ers in the fourth round of the 1987 NBA Draft. (Courtesy of The University of Tulsa.)

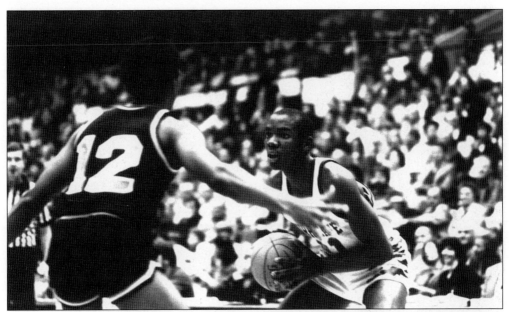

Byron Boudreaux played for the Golden Hurricane from 1983 to 1987. Boudreaux is one of just six TU players to appear in four NCAA Tournaments. He led Tulsa as a junior with 158 assists and as a senior with 171 assists. Boudreaux also paced the team in steals both seasons with 42 and 37 respectively. He is ranked second on TU's all-time assists chart (457) and 15th on the all-time steals list (119). He went on to a college coaching career, including time as an assistant at Oral Roberts, Arkansas, and Washington State. (Courtesy of The University of Tulsa.)

Pictured from left to right are David Moss and Tracy Moore. The two players were Tulsa's star tandem from 1984 to 1987. Often referred to as "the M&M Boys," Moss and Moore collectively averaged 34.7 points per game during the 1986–87 season accounting for half of the team's overall scoring. Both were named First Team All-MVC that year. (Courtesy of The University of Tulsa.)

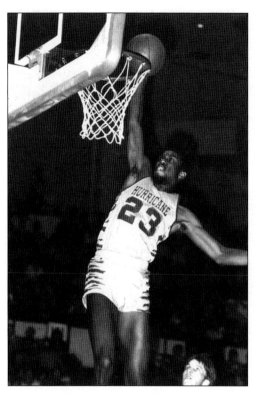

David Moss played for Tulsa from 1983 to 1987. He is one of just six TU players to play in four NCAA Tournaments. Moss led the Hurricane in scoring as a senior with 535 points (17.8 average) and paced the team in rebounding as a junior with 206 boards (6.4 average). In the first season for the three-point shot, Moss hit a team-leading 43 treys for a .409 average. He was named Second Team All-MVC in 1985-86 and First Team All-MVC in 1986-87. He was also a MVC All-Academic selection as a senior. Moss finished his career ranked 11th on TU's all-time scoring list with 1,391 points (11.3 average), 20th on the rebounding chart with 581 (4.7 average) and 13th on the steals list with 129. He was selected by the Portland Trailblazers in the fifth round of the 1984 NBA Draft. (Courtesy of The University of Tulsa.)

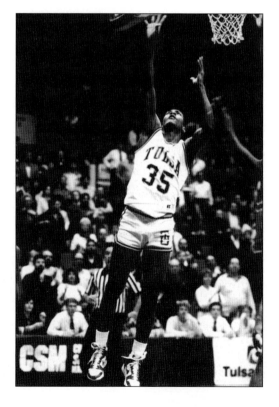

Tracy Moore played for TU from 1984 to 1988. He was an instrumental part in three NCAA Tournament appearances, two MVC regular season titles and one MVC Tournament title. Moore led the Hurricane in scoring as a sophomore with 539 points (16.8 average) and as a senior with 595 points (21.3 average). He was also the leading three-point shooter his senior season with 54 treys. His .467 three-point shooting average is tied for third among the top annual percentages. Moore is ranked third on TU's all-time scoring chart with 1,823 points (15.1 average). He was three times named First Team All-MVC (1985–86, 1986–87 and 1987–88). Moore went on to play professionally in the NBA with the Dallas Mavericks. (Courtesy of The University of Tulsa.)

Ray Wingard played for the Golden Hurricane from 1985 to 1989. As a junior, he led Tulsa with 208 rebounds and a .787 free throw percentage. He duplicated the effort as a senior pacing Tulsa with 256 rebounds and a .773 free throw percentage. Wingard was named second-team All-MVC following his senior season in 1988–89. (Courtesy of The University of Tulsa.)

Fallon Wacasey played for Tulsa from 1987 to 1989. In 36 games, he averaged 1.1 points and 1.0 rebounds and earned MVC All-Academic honors before switching to football. At the tight end position, he played a vital role on 1991 team that went 10-2 and won the Freedom Bowl. Wacasey would later be drafted by the Dallas Cowboys. (Courtesy of The University of Tulsa.)

The 1989–90 team went 17-13 on the season and earned a bid to play in the NIT. The team defeated Oklahoma State 95-80 early in the season at the Convention Center but had its season ended by the Cowboys in the first round of the NIT, 83-74, in Stillwater. Pictured, from left to right, are (front row) Lou Dawkins, Brian Loyd, Jamal West, Marcell Gordon, Reggie Shields, James McCallop and Jason Thompson; (back row) Michael Scott, Cornal Henderson, Lamont Randolph, Alyn Thomsen, Anthony Hines, Wade Jenkins, Jason Ludwig and Mark Giorgi. (Courtesy of The University of Tulsa.)

Brian Loyd played for TU from 1986 to 1990. He led Tulsa as a junior and senior with 38 and 50 three-pointers respectively. Loyd also paced the team in three-point field goal percentage both seasons with averages of .396 and .379. He was named MVC All-Academic in 1989–90. (Courtesy of The University of Tulsa.)

Alyn Thomsen played for the Golden Hurricane from 1987 to 1991. The seven-foot Dewitt, IA, native led Tulsa in blocked shots as a sophomore (20) and as a senior (47). He had his best season in 1990–91, averaging 4.9 points and 4.5 rebounds. He was a MVC All-Academic selection in 1988-89 and finished fifth on TU's all-time blocked shots chart with 86. (Courtesy of The University of Tulsa.)

Wade Jenkins scores with an emphatic two-handed jam against Southern Illinois as teammate Marcell Gordon looks on. Jenkins played for TU from 1987 to 1991. He led Tulsa in rebounding as a senior with 176 boards (6.3 rpg) and paced the Hurricane in blocked shots as a sophomore (18) and junior (22). Jenkins ranks 12th on the school's all-time blocked shot chart with 53. (Courtesy of The University of Tulsa.)

Michael Scott dunks the ball out of Byron Houston's reach as Tulsa defeated Oklahoma State 95-80 on December 17, 1989. Later that year, he fought back from a dangerous case of spinal meningitis to play in TU's NIT first round loss to OSU. Scott played for TU from 1987 to 1991. He ranks 17th on TU's all-time steals chart with 109. Scott was named MVC Defensive Player of the Year in his last two seasons at TU (1989-90 and 1990-91). (Courtesy of The University of Tulsa.)

Lamont Randolph played for the Golden Hurricane from 1988 to 1990. As a junior, he paced TU with 408 points for a 13.2 average. As a senior, Randolph was Tulsa's leading rebounder with 241 boards for an 8.0 average. He was twice named Second Team All-MVC. Randolph went on to a successful professional career in Europe where he most recently signed a contract to play in the Netherlands through the 2005 season. (Courtesy of The University of Tulsa.)

Reggie Shields drives on his defender in Tulsa's 72-61 victory against Kansas State on December 12, 1990. Shields played for TU from 1989 to 1991. As a senior, he led the team with 51 three-pointers and 154 assists. The previous season, Shields paced TU with 51 steals. He was named MVC Newcomer of the Year in 1989–90 after transferring from Polk Community College. Shields is ranked 10th on the all-time assists chart with 301. That total is the most by any two-year letterwinner. (Courtesy of The University of Tulsa.)

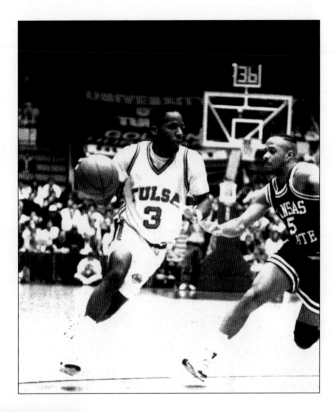

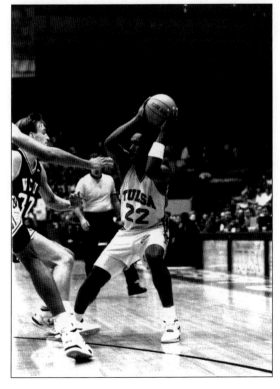

Jamal West looks to pass the ball in TU's 95-67 victory over Virginia Commonwealth on December 26, 1990. West played for the Golden Hurricane from 1987 to 1992. He originally came to TU on a football scholarship but decided to focus on basketball after his freshman year. As a sophomore, the Booker T. Washington High School product led TU with 126 assists (4.1 average) and 52 steals (1.7 average). West is ranked 16th on Tulsa's all-time assists chart with 252 and 14th on the school's all-time steals list with 124. (Courtesy of The University of Tulsa.)

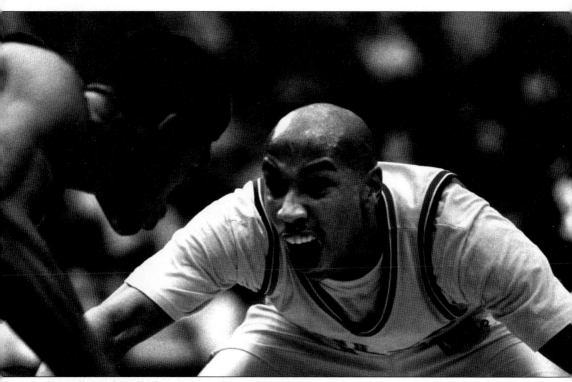

Marcell Gordon displays some of his trademark intensity on defense. Gordon played for Tulsa from 1989 to 1991. He was TU's leading scorer with 387 points (12.9 ppg) as a junior and 502 points (16.7 ppg) as a senior. Gordon also led Tulsa in steals as a senior with 55 and was named First-Team All-MVC. (Courtesy of The University of Tulsa.)

SIX
Tubby Time
1991–1995

After J.D. Barnett's departure, there was a significant movement by some Tulsa businessmen to entice Nolan Richardson back to TU. It was an intriguing thought and TU President Robert Donaldson and Athletic Director Rick Dickson brought the former coach to Tulsa for an interview. An offer was never officially made and Richardson publicly restated his commitment to the University of Arkansas. Tulsa also took looks at former assistant Scott Edgar, Oklahoma assistant Mike Mims and Oklahoma City University head coach Darrel Johnson.

Eventually, TU would take a long, hard gaze towards the Southeast. The Southeastern Conference, that is, where the Kentucky Wildcats were making a return to glory under run-and-gun coach Rick Pitino. He was flanked by an associate head coach named Orlando "Tubby" Smith. Smith was in his second year at Kentucky after spending time at South Carolina and Virginia Commonwealth where, ironically, he worked with Barnett for six years.

"I didn't know much about Tubby Smith, but I knew a lot about Kentucky," Collier says. "After his press conference, I was already wired up for the next season. I was going to do whatever he asked me to do and work as hard as he wanted me to and help the team get better."

Smith made an immediate impression on everyone around him. His personable, friendly nature was infectious. He was a hard guy not to like. On the court, however, Smith got off to a rocky start, losing five of his first six games. Teams like TCU, Brigham Young, UAB, Arkansas and Oklahoma State gave the rookie coach a not-so-warm welcome. But the team was patient and knew things would get better. Collier was enjoying his newfound freedom on offense. As a freshman, he took just two three-point shots. In Smith's first season, he hit 38 of 100 attempts from long distance.

"I always felt I could shoot the three-pointer but I never really shot enough in a game," Collier says. "When [Smith] first arrived, I remember he put in a tape of Kentucky and how quickly they shot the three-pointer. That was a very fast-paced, exciting style of basketball."

Smith's players began catching on to the new up-tempo, pressing style and by season's end, the team nearly made a run for the NCAA Tournament. Tulsa lost to Southwest Missouri State in the MVC Championship Game 71-68 and finished 17-13 with no postseason bids. Point guard Mark Morse was named MVC Newcomer of the Year and First Team All-MVC while Collier made a quantum leap to Second Team All-MVC recognition.

In 1992–93, preseason expectations were dashed by an unusual set of circumstances. The entire athletic department was placed on one-year probation and suspended from any postseason play. TU's basketball team felt the NCAA's heavy-handed blow due to infractions committed by Tulsa's track and field program. The Hurricane gutted out a 15-14 record and finished fourth in the MVC. The Hurricane lost its final game 106-80 at the hands of Southern Illinois in Carbondale. Alvin "Pooh" Williamson was a sophomore on that team.

"I can remember that day like it was yesterday," Williamson says. "Right after we finished practice, [Rick Dickson] was there and he sat us all down and went through the entire situation. It had an effect on us. The guys played that entire season and tried to get that out of their heads. It wasn't that bad until it got to March. And then we lost that last game horribly. It was a bad situation."

Heading into the 1993–94 season, no one knew how the players would rebound from the previous year's devastating turn of events. Bruce Howard entered his first season as the "Voice of the Golden Hurricane" and says everyone got their first clue when top-ranked Arkansas visited the Convention Center on December 23, 1993. Seemingly shell-shocked by TU's resilient attitude and tenacity, Arkansas couldn't shake the Hurricane. The game eventually went into overtime, during which Corliss Williamson hit a shot with 1.4 seconds left to give the Razorbacks the 93-91 victory.

"We knew that anything was possible if you work hard enough," Collier says. "That's what Coach Smith always told us. But we didn't know how good we could actually become until the Arkansas game. You could feel the sense of urgency for them. We actually put fear in their eyes. After that, we felt like we could compete with just about any team in the nation. That was a turning point for us."

Tulsa went 15-3 in MVC play that year and headed to the conference tournament as the favorites to claim the automatic NCAA berth. But the Hurricane ran into a hungry Northern Iowa team in the semifinals and lost 79-73. The team was left to hope and pray for an at-large bid.

"They weren't just one of the last teams to be selected that year," Howard says. "They were announced as the last 5-12 matchup. That was a very unsure situation. They were clearly on the bubble. Sometimes when teams feel fortunate to get in, they play a little more relaxed and with a little more reckless abandon. But to think that they could beat UCLA and Oklahoma State was pretty much unimaginable."

TU headed into the game against #17-ranked UCLA as decided underdogs. When asked about their opponent, some of the Bruins didn't even know where Tulsa was. It made for great headline material, but Williamson says the ignorant insult really didn't play a motivating factor. "Just being in the NCAA Tournament had us fired up," he says. "We didn't even really know about what they said. It didn't make them look good, but we were fired up to have a chance to play and prove ourselves."

UCLA won the opening tipoff, set up a play and missed an open shot. From there, Williamson says the stage was set for the most unbelievable half of basketball in TU history.

"Gary [Collier] rebounded it and kicked it to me," Williamson recalls. "Tyus Edney came that close to stealing the outlet pass. I got it, dribbled the length of the court and hit a shot. From that one shot, we just snowballed. Who knows? If Edney had made that first shot, it might not have been like it was. If he had stolen that pass and made a layup, who knows what might have happened? It started perfect and from then on it was just crazy."

With 6:19 left in the first half, Tulsa's lead had ballooned to 46-17. The Hurricane couldn't miss and Jim Harrick's team, led by Ed O'Bannon, didn't have an answer. Tulsa shot a blistering 58 percent from the field and took a 63-38 lead into the locker room at halftime. "It was surreal," Williamson says. "I can go through that game just like it happened a minute ago. It was just one of those games you never forget. If I live to be 80, I bet I'll still be able to remember that game."

In a single game, Tulsa was officially on the map. There had been flashes of success in previous eras, but nothing like this had ever transpired on such an enormous stage. The

Hurricane had defeated the UCLA Bruins 112-102 led by Collier's 34-point performance and freshman Shea Seals' 20-point, nine-rebound effort. Williamson chimed in with 20 points, eight assists and no turnovers. Jimmie Tramel covered the Hurricane's NCAA run that season for the *Tulsa World* and ponders the "what ifs."

"Tulsa was probably the last at-large team to get in and play UCLA," Tramel says. "If just one other team that isn't supposed to win a conference tournament wins, Tulsa goes to the NIT and the face of destiny changes. Isn't it amazing what one game can do? Tulsa didn't just beat UCLA. They blew them out of the water. I've talked to some UCLA coaches since then who were just in awe of what happened. Tulsa was absolutely at a magic level in that game."

Waiting in the wings was a #19-ranked Oklahoma State team that had defeated Tulsa 73-61 back in December. With the presence of "Big Country" Bryant Reeves in the middle, TU was faced with a challenging matchup problem. In the first half, Reeves had his way, hitting eight of 11 shots and scoring 19 points.

Tulsa faced a 50-39 deficit at the break and desperately needed to contain Reeves. Smith and his staff called an audible and devised a plan to slow the future NBA player down. TU placed a post player, either Rafael Maldonado or J.R. Rollo, behind Reeves and another player, usually Collier, on the front. It became more difficult to get the ball to Reeves and other OSU players were forced to hit jump shots. The plan worked and Reeves scored 13 scattered second-half points. Tulsa chipped away and took the lead, 77-75, on a Williamson three-pointer with 1:42 left to play.

OSU reclaimed that lead on a baseline three-pointer by Randy Rutherford. But after Dawkins missed the front end of a one-and-one bonus, Collier plowed in for the rebound and put back the layup, giving Tulsa the 79-78 advantage. Reeves missed a point-blank shot in the lane and Seals collected the rebound. Tulsa milked the shot clock as the most famous play in TU history unfolded.

"I wanted to hold it until the last second of the shot clock," Collier says. "I remember having the ball in my right hand with the dribble. I crossed over to the left and Lou's man came over to help out. I wanted to shoot the shot, but I passed it over to Lou. He's not a renowned three-point shooter, but that was the biggest shot he's ever made in his career."

Dawkins hit the shot and raced back down the court with his arms raised high and mile-wide smile on his face. On the ensuing play, Oklahoma State's Brooks Thompson missed a shot and Reeves got the rebound and a layup with two seconds left to make the final score 82-80. Again, Tulsa had been led by Collier who scored 25 points. Williamson added 20 points and another turnover-free effort at the point. Seals scored 13 and picked up a team-leading eight rebounds. All told, Tulsa had made history by reaching its first appearance in the Sweet 16.

As fate would have it, Tulsa was lined up for another rematch, this time against Nolan Richardson's top-ranked Arkansas Razorbacks. TU had given the Hogs all it could handle in December and the players knew the element of surprise was off the table. Arkansas was also playing at a higher level than three months earlier and Tulsa found itself standing between a steamroller and the national championship. Williamson describes the game as "a blur." Collier was disappointed by the 103-84 loss, but admits he wasn't surprised at the outcome.

"They weren't going to underestimate us like they did the first time," Collier says. "They came out and played harder. I'm not ashamed to say that they had a much better team than us. We felt like that if we could keep it close, we might have a shot at the end. But they did a good job jumping out on us early."

Tulsa's magical season was over. The Hurricane finished 23-8 and received numerous individual honors. Smith was named MVC Coach of the Year. Collier was named First Team All-MVC and Player of the Year. Seals earned MVC Freshman of the Year and Newcomer of the Year honors and Dawkins merited Second Team All-MVC accolades.

As the 1994–95 season approached, TU's returning players were faced with the challenge of living up to that groundbreaking team. Collier and Dawkins were gone, but Seals, Williamson and Kwanza Johnson provided what looked like a winning nucleus. "The bar had been set pretty

high and we didn't want to drop the ball," Williamson says. "We all talked about that. It was our motivation."

TU started with a strong 9-3 record losing only to Oklahoma State, Oklahoma and Arkansas. The Hurricane made another successful trek through the MVC and claimed its second straight regular season title. Favored to win the MVC Tournament in St. Louis, Tulsa waltzed by Wichita State and Bradley. But in the championship game, the team faltered and again was denied the postseason crown with a 77-62 loss at the hands of Southern Illinois.

This year, there was little doubt that TU would receive an at-large bid. In fact, Tulsa was rewarded for its season's efforts (and probably some for its exploits the year before) with a #6 seeding. In Albany, N.Y., the Hurricane was forced to wait through a triple overtime game between Old Dominion and Villanova. They would not tipoff against Illinois until 11 o'clock that night.

The wait proved to be a deterrent to quality basketball on both sides. Illinois had played better throughout the contest and late in the game, TU found itself trailing by one point. Howard recalls a play that he refers to as "one of the great shots in Tulsa history that nobody remembers."

"With fifty seconds left, we were down by one with the ball," Howard says. "Cordell [Love] threw up a three-pointer and it came off the rim. Ray Poindexter got the rebound and kicked it to Pooh on the left side. He makes a three and gets fouled. We go from being down one to having a three-point lead. Illinois panicked and threw up a three. We got the rebound and all of the sudden the team that had struggled the whole game wins."

With the 68-62 victory, Tulsa advanced to play an Old Dominion team that had been drained in a triple overtime marathon. The Hurricane advanced relatively easily with a 64-52 win. TU now faced a dominant Massachusetts team that was expected to reach the Final Four. The Minutemen featured a freshman phenom named Marcus Camby. With flashbacks to the previous year's Arkansas trouncing, Tulsa wanted desperately to avoid the blowout bug. Instead, TU found itself overmatched in a hostile environment. The game at East Rutherford, New Jersey, was virtually a home game for UMass, who won 76-51.

Tulsa's season was over with an impressive 24-8 record. Seals and Williamson were both named First Team All-MVC and Smith repeated his MVC Coach of the Year performance. While some will debate Smith's place in TU basketball history, Tramel says there's no question he deserves much of the credit for the success that would follow in his wake.

"If you give Nolan [Richardson] credit for birthing the baby, then you have to give Tubby credit for raising the baby," Tramel says. "Tulsa had never won a first round NCAA Tournament game before Tubby. There was no reason to believe it could happen until you saw it happen. When Tubby took Tulsa to back-to-back Sweet 16s, that really launched, with all due credit to what Nolan accomplished, the golden era of TU basketball. Tubby created what is now the most pressure packed job in the WAC. People expect Tulsa's players to win because the word "Tulsa" is on their jerseys, period."

By the end of the 1993–94 season, Smith's name was routinely being tossed around as a possible candidate for other jobs. Houston, Kansas State and Oklahoma were a few schools that showed interest in the rising star. When Georgia called on Smith after the 1994–95 campaign, it gave him the chance to get into the Southeastern Conference and a little bit closer to his dream job at Kentucky. Tulsa found itself again hoping to find another young leader ready, willing and able to pick up where Smith had left off.

Orlando "Tubby" Smith coached the Golden Hurricane from 1991 to 1995. In his first head coaching job, he guided Tulsa to an overall 79-43 record over four seasons, including the school's first back-to-back Sweet 16 appearances in 1993–94 and 1994–95. Smith led TU to a pair of first place finishes in the MVC and was twice named MVC Coach of the Year. He coached eight all-conference performers and two league Newcomers of the Year (Mark Morse and Shea Seals). In 1995, he left Tulsa for Georgia where he spent two seasons. From there, he moved to Kentucky where he led the Wildcats to the National Championship in his first season (1997–98). (Courtesy of The University of Tulsa.)

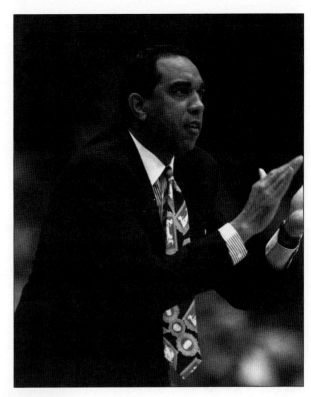

Shawn Finney served as an assistant coach under J.D. Barnett during the 1990–91 season and stayed at Tulsa to work under Tubby Smith from 1991 to 1995. He followed Smith to Georgia and then Kentucky before taking his first head coaching job at Tulane. (Courtesy of The University of Tulsa.)

Ron Jirsa was an assistant coach under J.D. Barnett from 1985 to 1988 then returned to TU to work under Tubby Smith from 1991 to 1995. He followed Smith to Georgia then took over the head job when Smith went to Kentucky. After two years at Georgia, he went to Dayton as an assistant coach and then landed the head coaching position at Marshall. (Courtesy of The University of Tulsa.)

Jeff Schneider served as an assistant coach under Tubby Smith from 1991 to 1994. He spent the previous two seasons working with J.D. Barnett. Schneider left Tulsa following the 1993–94 season to take an assistant coaching job at Washington State. He later assumed the head coaching job at Cal Poly-San Luis Obispo, where he spent six years. Schneider is now a nationally-renowned speaker and basketball clinician. (Courtesy of The University of Tulsa.)

Mark Morse played point guard for Tulsa from 1991 to 1993. As a junior, he led TU in scoring with 449 points (14.9 ppg) and steals with 66. He duplicated the feat as a senior by scoring 502 points (17.4 ppg) and compiling 65 steals. Morse was named the MVC Newcomer of the Year in 1992 and he was twice named First-Team All-MVC (1991-92 and 1992–93). He ranks 14th on TU's all-time assists chart with 285 and ranks 12th on TU's all-time steals chart with 131. (Courtesy of The University of Tulsa.)

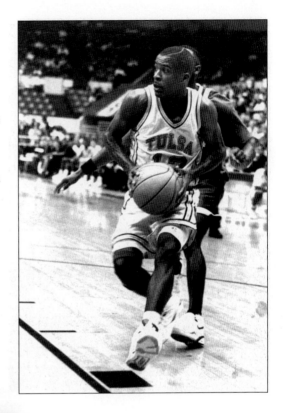

Jeff Malham played for TU from 1991 to 1993 after transferring from Northeastern Oklahoma A&M. As a senior, the Broken Arrow, OK, native led Tulsa in rebounding with 168 boards for a 5.8 average and paced the Hurricane in free throw percentage with a .847 average (83 of 98). Malham went on to play professionally in the Netherlands. (Courtesy of The University of Tulsa.)

In 1993, Bruce Howard became the Voice of the Golden Hurricane, calling the action at all TU football and basketball games. He has since been named Director of Broadcasting at The University of Tulsa. (Courtesy of The University of Tulsa.)

The 1993–94 team set a new standard by reaching the NCAA tournament's Sweet 16 for the first time in school history. Tulsa won the regular season MVC title and earned one of the last at-large bids. The Hurricane shocked the nation by upsetting #17-ranked UCLA and #19-ranked Oklahoma State. Tulsa's run ended with a loss to the eventual national champions from Arkansas. The team is the fourth-highest scoring squad in school history with an 83.4 average. Pictured, from left to right are (front row) Alvin "Pooh" Williamson, Cordell Love, Jay Malham, Gary Collier, Lou Dawkins, Shea Seals, Kwanza Johnson and Kevin Grawer; (back row) Assistant Coach Shawn Finney, Assistant Coach Jeff Schneider, Craig Hernadi, Rafael Maldonado, J.R. Rollo, Dewayne Bonner, Assistant Coach Ron Jirsa, Head Coach Orlando "Tubby" Smith. (Courtesy of The University of Tulsa.)

Players from the 1993–94 team huddle up prior to a game during its 1994 NCAA tournament run. Pictured from left to right are, J.R. Rollo, Kwanza Johnson, Craig Hernadi, Rafael Maldonado and Dewayne Bonner. (Courtesy of The University of Tulsa.)

Shea Seals chases down a loose ball against UCLA's Charles O'Bannon. TU defeated the fifth-seeded Bruins 112-102 in the first round of the 1994 NCAA Tournament. Seals came to Tulsa as the program's most highly-touted recruit. The Tulsa, OK, native from McLain High School made an immediate impact setting freshman records in scoring (470 points), scoring average (16.8), assists (97), steals (51) and three-pointers (75). Seals was named MVC Freshman of the Year, MVC Newcomer of the Year and Honorable Mention All-MVC. He also received Third Team Freshman All-America honors from Basketball Times and Fourth Team Freshman All-America accolades from Basketball Weekly. (Courtesy of The University of Tulsa.)

Lou Dawkins clears out after a rebound, bringing Oklahoma State's Brooks Thompson to his knees. Later in the game, Dawkins would hit a three-point shot to secure TU's 82-80 victory in the second round of the 1994 NCAA Tournament. Dawkins played for the Golden Hurricane from 1989 to 1994. He sat out all but three games of the 1990-91 season with a knee injury. In his senior season, Dawkins led TU with 138 assists and 52 steals. He finished his career ranked fourth on the all-time assists chart with 339 and ranked sixth on the all-time steals list with 176. That same year, Dawkins was named MVC Defensive Player of the Year and Second Team All-MVC. In 2004, he was named Head Coach at his high school alma mater in Saginaw, MI. (Courtesy of The University of Tulsa.)

Gary Collier drives to the hoop in a game at Oklahoma State. Collier played for the Golden Hurricane from 1990 to 1994. As a senior, he led TU in scoring with 710 points (22.9 average) and in rebounding with 209 boards (6.7 average). His point total is the fourth highest in school history. That season, he also set a Tulsa record with 93 three-pointers and led the team with a .463 shooting average from three-point range. In 1993-94, Collier was named MVC Player of the Year and First Team All-MVC. He received Second Team All-MVC honors in both 1991-92 and 1992-93. Collier finished his career as the fourth-leading scorer in school history with 1,610 points. He is also ranked 19th on TU's all-time rebounding list with 587. Collier was drafted by the Cleveland Cavaliers in the second round of the 1994 NBA Draft. He went on to have a successful 10-year career in Europe including a 2004 stop in France. (Courtesy of The University of Tulsa.)

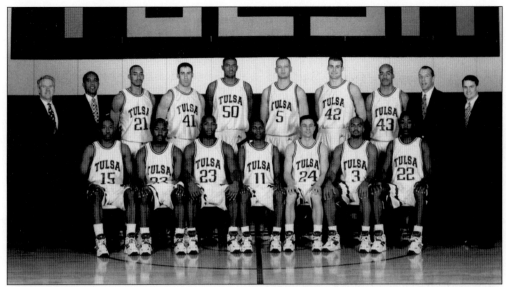

The 1994–95 squad repeated its efforts from a year earlier by reaching the Sweet 16. In Coach Tubby Smith's final season, the team went 24-8 and won the MVC regular season title. TU received an at-large bid to the NCAA Tournament and defeated Illinois and Old Dominion before losing to #7-ranked Massachusetts. Pictured, from left to right, are (front row) Cordell Love, Jamie Gillen, Kwanza Johnson, Alvin "Pooh" Williamson, Kevin Grawer, Jason Williams and Dewayne Bonner; (back row) Assistant Coach Mike Sutton, Head Coach Orlando "Tubby" Smith, Shea Seals, Craig Hernadi, Rafael Maldonado, Ray Poindexter, J.R. Rollo, Rasheed Malik, Assistant Coach Ron Jirsa and Assistant Coach Shawn Finney. (Courtesy of The University of Tulsa.)

Alvin "Pooh" Williamson eyes the hoop in TU's 82-80 victory against Oklahoma State at the 1994 NCAA Tournament. Williamson played for Tulsa from 1991 to 1995. A Beggs, OK, native, he was TU's starting point guard in back-to-back Sweet 16 seasons. Williamson committed just three turnovers in six career NCAA Tournament games while averaging 38 minutes per contest. As a senior, he led TU with a .394 three-point field goal percentage and averaged 12.8 point per game. He was named First Team All-MVC and joined teammate Kwanza Johnson on the MVC All-Defensive Team. Williamson is ranked 15th on TU's all-time assists chart with 277. (Courtesy of The University of Tulsa.)

Kwanza Johnson played for the Golden Hurricane from 1993 to 1995 after transferring from Rose State College. He started his athletic career as a freshman at Kansas where he was on a track and field scholarship. In his two seasons at Tulsa, Johnson played in 63 games and averaged 6.4 points and 4.8 rebounds. As a senior, he was named to the MVC All-Defensive Team. After completing his bachelor's degree in economics, he went on to earn a law degree from The University of Tulsa College of Law in 1999. (Courtesy of The University of Tulsa.)

J.R. Rollo locks arms with Oral Roberts post man Blake Moses in TU's 90-78 loss at the Mabee Center on December 30, 1995. Rollo played for Tulsa from 1992 to 1996. He was a key role player in the paint on three NCAA Tournament teams. As a sophomore, Rollo paced the Hurricane with 22 blocked shots. (Courtesy of The University of Tulsa.)

SEVEN

Mr. Robinson's Neighborhood

1995–1997

As TU was searching for the perfect replacement for a man that some believed was the perfect coach, speculation ran rampant as many members of the media and fans pondered the possibility of a former player returning to take the helm. Names like Mike Anderson and Paul Pressey were tossed around, but ultimately the administration took a page from the hiring of Smith and looked for an assistant coach from an established powerhouse.

"Steve Robinson came out of nowhere to get that job," Bruce Howard says. "He was so incredibly prepared and had his ducks in a row in terms of how he wanted to go about his business. He was very impressive. He was totally different from Tubby. Tubby was outgoing and gregarious. Steve was just a shy guy. He was very reserved and quiet. Those two couldn't have been any more different."

If there was any pressure to fill the enormous hole left by Smith's departure, Robinson certainly didn't show any signs of cracking. He fully understood what his predecessor had meant to the TU basketball program. "It was exciting for me," Robinson says. "It was my first head coaching job. I was following a guy that a lot of people loved in Tulsa. I just wanted to come in and try to work hard and do the things that I had been taught by being at Kansas with Coach [Roy] Williams."

Robinson's hiring caused at least one recruit to second guess his decision. Rod Thompson was preparing to transfer from Northeastern Oklahoma A&M. He was coming to TU despite the fact that Smith's son Gigi, a talented point guard, was expected to join his father that same season. The day Thompson was supposed to sign was the same day Smith revealed his decision to take the Georgia job. When Anderson didn't get the job, he considered taking an offer to play for Charlie Spoonhour at St. Louis. But after Robinson met with the Beggs, OK, native to reseal the deal, Thompson chose to follow in Pooh Williamson's steps after all.

After jumping out to a quick 5-0 start, Tulsa received its earliest national ranking (#25) since the 1982–83 season. Lying in wait was an improving Oral Roberts club under the direction of up-and-coming coach Bill Self. He designed an offensive scheme specifically aimed at taking advantage of Robinson's aggressive style of defense. ORU frustrated Tulsa all game long with a series of back door cuts and easy layups.

"We'd gotten off to a good start then I remember us going really cold and hitting a stretch where

we couldn't hit a basket," Robinson says. "They went on a run and pulled away from us and we could not catch up. It was a good basketball game and that night they were the better team."

Tulsa rebounded with an ugly 57-53 win against Oklahoma State, then prepared for the school's last season in the Missouri Valley Conference. The Hurricane entered conference play with a bulls eye on its chest thanks in part to the impending exit as well as the recent success. But the bigger issue for TU was finding a replacement for Williamson at the point guard position. Thompson was just a sophomore and wasn't yet ready for a starting role. That's when a 6-5 senior forward named Dewayne Bonner volunteered his services.

"[Dewayne] wound up being our starting point guard for the entire season and he did a fantastic job," Robinson says. "I remember at the beginning of the year, Dewayne was bringing the ball up the court and he was kind of dribbling it sideways and backing it down the court. As the season progressed, he would bring it in transition and push it and make decisions."

By season's end, Bonner had transformed into a confident starting ball-handler that led the team with 147 assists, averaging 4.9 per game. Tragically, his life was cut short in May of 2002 at the age of 28 when he lost his fight with liver cancer. Robinson had one last chance to visit with Bonner a year earlier while in Dallas on a recruiting trip.

"I loved Dewayne Bonner," Robinson says. "Here's a guy that just did what I asked him to do. I feel like I was able to help give him something back in return. Sometimes life can be so unfair and it's unfortunate that his life was cut short. He was a wonderful human being and a role model to a lot of athletes that come through the program."

Tulsa went to St. Louis for the MVC Tournament knowing it would likely have to win it all to earn an NCAA bid. The team had finished third in the regular season after a competitive battle with Bradley and Illinois State. TU's run through the tournament would prove to be much less challenging with double digit victories against Evansville and the aforementioned Bradley and Illinois State.

With the automatic NCAA bid, TU was sent to Milwaukee, Wisconsin, for a first round meeting with #24-ranked Louisville. Thompson remembers feeling overwhelmed by his surroundings the moment the team arrived for its shootaround the day before the game.

"I went from playing in a gym the size of a Cracker Jack box to playing where the Milwaukee Bucks play," he says. "I will never forget it. I was just in awe. I was just kind of looking around and Coach Robinson looked at me and said, 'Man, Rod, you'd better wake up. You'd better realize you're not in Beggs, Oklahoma.'"

Thompson and his teammates were wide awake for the tipoff and promptly took the lead. Freshman Michael Ruffin had a breakout game, scoring 21 points and nabbing 16 rebounds.

With 2:59 to go in the game, the Hurricane was winning 72-59 and seemingly had the game in hand. Tulsa had outplayed the Cardinals in every aspect of the game with one exception— turnovers. The Hurricane committed a rash of miscues, including several traveling violations late in the game. All told, TU ended with a season high 27 turnovers. This allowed Louisville to make a comeback that sent the game into overtime. Even still, Tulsa had its opportunities to win the ball game.

"Towards the end of the game, I made a shot that probably would have won the game," Thompson says. "I made an up-and-under move and scored, but they called me for traveling. After the game, [Robinson] told me that it wasn't a walk. A couple of years later, he told me that the NCAA was using that play at clinics to show officials how not to call traveling."

With the game tied and seconds remaining, Louisville hit a field goal and walked away with the 82-80 victory. It was a disheartening end to what had been a good first season for the new head coach. Tulsa finished 22-8 and team superstar Shea Seals was named First Team All-MVC.

Robinson's second year was ripe with expectations. Seals was a senior, Ruffin was a year older and the incoming recruiting class included an exciting prospect named Eric Coley. Thanks to past success, TU was able to land a spot in the preseason NIT. The Hurricane traveled to play a UCLA team that was just two years removed from its national championship. Head Coach Steve Lavin had recently taken over for Jim Harrick who lost his job in a fraudulent expense report scandal.

The fact that UCLA rarely lost at Pauley Pavilion meant nothing to Tulsa. The team's upset of the Bruins in the 1994 NCAA Tournament was a distant memory.

"The thing I liked about our team is they always expected to win," Robinson says. "It didn't matter who we were playing or where we were playing, they expected to win."

The trip to Los Angeles was an experience the team would never forget. They met Monday Night Football announcer Al Michaels at the airport and stayed in the same hotel with the Utah Jazz. Former Kansas star Greg Ostertag accompanied the team to practice. TU also received special visits from former Lakers G.M. Jerry West and NBA legend Magic Johnson. The game itself wasn't so posh and, in fact, was a battle to the bitter end. After blowing an eight point lead with 2:20 to play, TU was forced into overtime where freshman Zac Bennett from Union High School in Tulsa grabbed a rebound and was fouled on an attempted layup. With two seconds remaining, he missed the first of two free throw attempts but according to Howard, "massaged" the second one through the hoop to give TU a 77-76 lead. UCLA's inbounds pass attempt was errant and Tulsa had once again played spoiler to the #5-ranked team.

"You just hoped [Zac] could knock one of those free throws in," Robinson says. "He stepped up and showed some toughness and got the job done."

TU earned a second round game at home against Oklahoma State and dominated in a 72-54 contest. Next up for the Hurricane was a trip to New York for the semifinals. Robinson recalls that most of his players had never traveled east of the Mississippi River. Tulsa lost its game against Duke 72-67 but came back to defeat Evansville 55-51 in the consolation game. The rest of the non-conference schedule was dotted with high quality wins including games Temple, Oklahoma and Oral Roberts.

Next up was TU's inaugural season in the Western Athletic Conference. Tulsa made an immediate impact, finishing second in the Mountain Division. The Hurricane opened with a blistering defensive performance against Rice for the 65-33 win. The team was then forced to play a pair of games at the Mabee Center due to a scheduling conflict with the Convention Center. TU upset #12-ranked New Mexico (80-57) followed by a win against UTEP (63-52) and the legendary coach Don Haskins.

The Hurricane nearly pulled off another shocker against #5-ranked Utah but future NBA player Andre Miller hit a shot at the buzzer to give the Utes a 56-54 victory. Keith Van Horn and Michael Doleac also starred on Rick Majerus' team. The following game, Tulsa traveled to Fort Worth to face Billy Tubbs and TCU. Ruffin exploded for 30 points and 24 rebounds in TU's 128-84 victory. Robinson describes him as "the most advanced defensive player" he's ever coached.

After dominating TCU in two previous contests, Tulsa would ironically lose to the Horned Frogs in the second round of the WAC tournament. Still, the Hurricane had earned the respect of the NCAA selection committee and earned an at-large bid and #5 seeding. TU dominated Boston (81-52) and moved on to face #14-ranked Clemson.

"It was pretty obvious that [Clemson's] aim was to stop Shea and the best way to stop him was to get him into foul trouble," Howard says. "(Head coach) Rick Barnes did a great job of coaching in that I assume he instructed his kids to fall down every time Shea Seals touched them."

Thompson says he later watched the game tape and couldn't believe how "outlandish" some of those calls were. Seals sat on the bench most of the first half with three early fouls. The team fought through without their star player and kept the game close but ultimately fell 65-59. The season was over and TU finished up 24-10. Seals was named First Team All-WAC and Ruffin earned All-Defensive Team honors. Thompson believes the season is one of the most underrated in school history. Perhaps one more NCAA Tournament win would have secured that team's place in TU's hallowed history.

If Tulsa was going to get back to the Sweet 16, it would do so without Robinson. In a surprising turn of events, he took the head coaching job at Florida State. Later on, he would find himself back in the Roy Williams camp as an assistant coach at Kansas for a second term and then North Carolina.

"That was more surprising because of the abrupt nature of it," Howard says. "It just happened so

quickly. With Tubby, there was always speculation. With Steve, it was more surprising because he had just agreed to a seven-year deal. The Florida State thing happened so quickly and it surprised everybody."

Tulsa's coaching carrousel was officially reopened for business and newly appointed Athletic Director Judy MacLeod was about to take her first stab at the controls. The end result would shake up the city of Tulsa and ultimately the entire college basketball world.

Steve Robinson cuts down the nets after TU's defeat of Bradley in the MVC Tournament title game. It was Tulsa's final year in the conference and resulted in the school's fourth tournament championship. Robinson served as the Golden Hurricane head coach from 1995 to 1997. He came to Tulsa from Kansas where he had worked closely with Roy Williams. Robinson recorded a 46-18 mark and the school's fifth best winning percentage among all coaches (.719). His teams were known for their swarming half court defense. The 1995–96 squad held opponents to a combined .392 field goal percentage and 65 points a game. Robinson led the Golden Hurricane to a pair of NCAA tournament appearance and is one of three Tulsa coaches to make the Big Dance in his first year. He coached TU to the school's second biggest upset when the Hurricane defeated #5-ranked UCLA 77-76 in overtime. Later that year, the team upended #12 New Mexico 80-57. At the end of the season, Robinson left Tulsa to take the head coaching job at Florida State. He eventually returned to the assistant coaching ranks at Kansas and then North Carolina. (Courtesy of The University of Tulsa.)

Opposite, bottom right: Dewayne Bonner defends the top of the key in Tulsa's 57-53 victory against Oklahoma State on January 2, 1996. Bonner played for TU from 1992 to 1996. As a senior, the 6-5 small forward was converted to the point guard position, where he led the Hurricane to an NCAA Tournament appearance. Bonner paced the Hurricane with 147 assists for a 4.9 average. At the end of the season, he was named to the MVC's Most Improved Team. Tragically, his life was cut short by liver cancer in May of 2002 at the age of 28. (Courtesy of The University of Tulsa.)

Opposite, bottom left: Cordell Love played for TU from 1992 to 1996. After missing out on the team's Sweet 16 run in 1994 due to academics, Love bounced back to be a long distance offensive threat. As a senior, he led Tulsa in three-point field goals (71) and three-point shooting percentage (.346). (Courtesy of The University of Tulsa.)

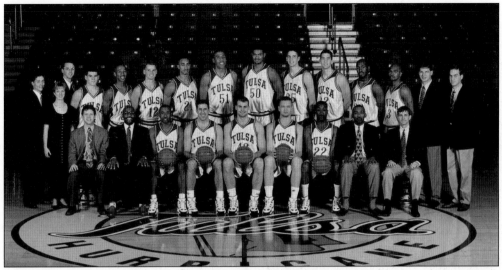

The 1995–96 team went 22-8 in Steve Robinson's first year as the head coach. The team set a new school mark for points scored in a game when it defeated Prairie View A&M 141-50 on December 7. The 91-point victory set the NCAA record for largest margin of victory against an NCAA Division I opponent. Other key victories included defeats of Temple, Oklahoma State and Alabama-Birmingham. Tulsa claimed the MVC Tournament title in its last year with that conference. The Hurricane lost to Louisville 84-80 in overtime at the first round of the NCAA Tournament. Pictured, from left to right, are (front row) Assistant Coach Matt Wingate, Head Coach Steve Robinson, Cordell Love, Craig Hernadi, J.R. Rollo, Ray Poindexter, Dewayne Bonner, Assistant Coach Coleman Crawford and Assistant Coach Jim Platt; (back row) Manager Tony Bowles, Manager Amy Stroud, Manager Tim Juhlin, Jeff Platt, Rod Thompson, Jonnie Gendron, Shea Seals, Michael Ruffin, Rafael Maldonado, John Cornwell, Zac Bennett, Jamie Gillin, Jason Williams, Trainer Kevin Beets and Trainer Dan Newman. (Courtesy of The University of Tulsa.)

Ray Poindexter eyes the basket for a dunk in Tulsa's 73-57 victory against New Mexico State on December 20, 1995. Poindexter played for the Golden Hurricane from 1994 to 1996. As a junior, the Sapulpa, OK, native led TU with 36 blocked shots. As a senior, Poindexter was Tulsa's second-leading rebounder with 193 boards (6.4 average) and ranked eighth in the MVC. He stands eighth on Tulsa's all-time blocked shot chart with 64. (Courtesy of The University of Tulsa.)

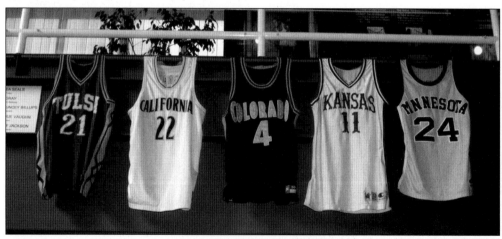

Pictured is Shea Seals' jersey hanging at the College Basketball Hall of Fame alongside other star players from the 1996–97 season. From left to right they are, #21 Shea Seals, #22 Ed Gray of California, #4 Chauncey Billups of Colorado, #11 Jacque Vaughn of Kansas and #24 Bobby Jackson of Minnesota. His 705-point performance as a senior ranks as the fifth best scoring total in school history. Seals was a two-time First Team All-MVC selection (1994–95 and 1995–96) and earned First Team All-WAC merits in 1996–97. He was twice named Honorable Mention All-American (1994–95 and 1995–96) and as a senior was tabbed Third Team All American by the Associated Press. Seals was also a finalist for the Naismith College Player of the Year award. He finished his career as TU's all-time scoring leader with 2,288 points. Seals is ranked third on the all-time rebounding chart (777), third in assists (388), third in steals (222) and first in three-pointers (299). He is the only Tulsa player to score 400 points or more in four seasons and is one of just six Hurricane players to play in the NCAA Tournament four times. His #21 jersey was retired just before the end of his senior season. (Courtesy of The University of Tulsa.)

Prior to his senior season, Shea Seals was a member of the 1996 USA Men's Under-22 World Championship Qualifying Team. He also played on an NCAA select team that played in an exhibition game against the Olympic Dream Team. Seals led all scorers with 20 points. After his senior year, Seals spent the 1997–98 season with the Los Angeles Lakers. He has played overseas in Spain, China, France and the Philippines and has also spent time stateside as part of the NBDL and the USBL. (Courtesy of USA Basketball.)

Rafael Maldonado defends against Bryant "Big Country" Reeves in TU's 82-80 victory over Oklahoma State. Maldonado played for Tulsa from 1993 to 1997. While he never led TU in blocked shots, he still managed to finish seventh on the school's all-time list with 79. Maldonado is just one of six players to appear in four NCAA tournaments. After leaving TU, he went on to a professional basketball career including a 2002 stint with Owensboro of the NABL. He was also a member of the 2004 Panama National Team. (Courtesy of The University of Tulsa.)

Rod Thompson played for TU from 1995 to 1998 after transferring from Northeastern Oklahoma A&M. As a senior, the Beggs, OK, native led TU in scoring with 466 points (15.0 average) and 71 three-pointers. Thompson was Tulsa's top assist man with 117 in each of his last two seasons. He was a steady free throw shooter, knocking down 209 of his 255 career attempts for an .819 average. In his final season, Thompson was named Second Team All-WAC. He stands eighth on TU's all-time assists chart with 318, the most among three-year letterwinners. (Courtesy of The University of Tulsa.)

Zac Bennett played for TU from 1996 to 1999. He ranks tied for 15th on TU's all-time blocked shots chart with 44, but he's most famous for his game-winning free throw on the road against UCLA in the pre-season NIT. Tulsa won that game 77-76 in overtime on November 20, 1996. Bennett transferred to Oklahoma Baptist after his junior season and eventually went on to play professionally overseas, including a stint in Austria. (Courtesy of The University of Tulsa.)

EIGHT
Self Defense
1997–2000

When Bill Self was named TU's 26th head basketball coach, it sent shockwaves throughout the local sports community. Self was certainly qualified and considered by most to be a hot commodity, but it was the fact that Tulsa had boldly snatched him from cross-town rival ORU that set the town abuzz. TU's players had already gotten wind of Self's demanding nature. Rod Thompson had been recruited by ORU, so his trepidation was two-fold.

"We had heard different things from ORU players so at first a lot of players weren't too pleased about it," Thompson admits. "At first it was a little awkward. I didn't know how he'd handle me knowing that I'd turned [his offer to play at ORU] down. When we first talked he told me, 'You can't run anymore. I'm finally going to be your coach.'"

Self brought with him an old friend from Oklahoma State named John Phillips. The two were assistants together under Leonard Hamilton. Phillips already had a great deal of knowledge of TU's basketball history. He was a graduate assistant with Jim King and had earned his Master's Degree from the school in 1978. Besides that, Phillips was a Tulsa native and grew up following the program.

TU opened the 1997–98 season with an 86-80 double-overtime win against Tulane. From there, the Hurricane traveled to Fairbanks, Alaska for the Great Alaska Shootout where they opened with an unheralded Gonzaga team. At halftime, Tulsa was down by 30 points and by the time the buzzer sounded, the Bulldogs had embarrassed the Hurricane 78-40. TU bounced back to win its next two games of the tournament, but came home mulling some cold, hard facts.

"After the Gonzaga game, I think we made an effort to understand how we could win and that was by playing great defense," Phillips says. "We were going to have to try to become a great defensive team and keep the scores low."

Back in Tulsa, the team blew a 20-point lead against Houston and lost 61-57. Phillips recalls walking off the court completely frustrated after a game in which Michael Ruffin had missed three point-blank layups. With Nebraska and star point guard Tyron Lue coming in two days later for an ESPN contest, Self and his staff were concerned about looking bad on national television. But Thompson's gritty play charged up the rest of the team. He scored 25 points and kept Lue at bay with a scattered 18-point performance. Tulsa won the game 85-68.

"Rod Thompson played the game of his career," Phillips says. "He just ate Lue up. That game gave us the confidence to know that we could be a good team.

The rest of the non-conference schedule was an emotional rollercoaster. TU defeated ORU 58-53 in Self's first game back at the Mabee Center. The Hurricane then dropped a 74-53 loss at the hands of eventual national champs Kentucky led by former TU coach Tubby Smith. At the same time, the Hurricane was fighting through a great deal of adversity. Before the season had started, the team lost Jamie Gillen due to academic probation. J.R. Cunningham's career was ended six games into the season with concussions and Eric Coley missed five games when his mother lost her battle with brain cancer.

As Tulsa approached WAC play, the coaches knew they had to rectify its problems on offense. Thompson was the team's primary scorer while doubling as the point guard. When TU traveled to San Jose State, they only had seven available players. Self decided to put junior college transfer Shawn Williams in as the point guard. For the last 13 games, Williams started and Thompson was freed up to concentrate on scoring. Tulsa won nine of those contests and came within two points of a 20-win season. At the WAC Tournament in Las Vegas, Zac Bennett missed the front ends of two one-and-one opportunities and the Hurricane lost to New Mexico 60-59.

Tulsa's season was over with a 19-12 record and the team had finished third in the WAC's Pacific Division. The Hurricane narrowly missed out on an NIT bid but made significant strides at the end of the year. Thompson was named Second Team All-WAC and Ruffin and Coley were named to the WAC All-Defensive Team. Ruffin and Gendron repeated their WAC All-Academic performances of a year earlier.

As the 1998–99 season approached, there was a heightened sense of anticipation. Not only was Self developing a group of players into a winning unit, a new era of TU basketball was being erected on the corner of 11th and Harvard. The Donald W. Reynolds Center represented The University of Tulsa's long overdue on-campus arena. Phillips says that he and Self walked to the construction site at least once a week, donned hard hats and took personal tours.

"It's amazing to see something like that," Phillips says. "To actually watch it go up, that was very meaningful to me."

TU played its first six home games at the Convention Center and won them all, including a 73-68 victory against ORU. On December 29, 1998, Tulsa officially christened the Reynolds Center with a 79-51 victory against Cleveland State. Self says it was "one of the most nervous games" in his tenure at Tulsa.

"This is the absolute true feeling I got that night," Phillips adds. "It wasn't about me. It wasn't about the players. I sensed a true love for the building from our fans. It was something that was theirs. It was like a Christmas gift that you've wanted forever and you thought you'd never get it. I could see our fans looking around in awe. Ever since then it's been that way. They love this arena."

The WAC season was a dogfight from start to finish. Tulsa had struggled at times, losing back-to-back road games against Air Force and UNLV, but emerged as a contender with a 72-62 victory against #24-ranked TCU. Because of the tight race, TU found itself battling for a spot in the WAC Tournament. The Hurricane traveled to Texas for two final games against SMU and TCU with a 7-5 conference record. Against SMU, Tulsa nearly succumbed to a miraculous last minute charge of three-point shots. TU lost an 11-point lead and trailed with seconds remaining.

"Brandon Kurtz gets an inbounds pass and dribbles 75 feet because nobody wanted to guard him," Howard recalls. "With his leg in the air, Brandon hits this little running five-footer that bounces around the rim and drops in with a second left and we win [78-77]."

Tulsa's defeat of TCU coupled with a pair of UNLV losses allowed the Hurricane to claim a share of the WAC's Pacific Division title. At the conference tournament in Las Vegas, Tulsa easily handled Fresno State, 85-56, but lost the next game to Utah 64-61 in overtime. The Hurricane earned an NCAA bid and was sent to Charlotte, NC for a first round contest against #18-ranked College of Charleston. With #1-ranked Duke waiting in the wings (and watching from the stands), TU played a flawless first half and with 15 minutes to go led 52-26. Charleston went on a 25-1 tear and the blowout was suddenly a game again.

"I remember Bill during one of those timeouts," Howard says. "He just brought the team over and he was the most calm and collected guy. I have this endearing memory of him being so incredibly calm in what seemed to be the most colossal collapse in the history of the NCAA Tournament."

Freshman Greg Harrington hit a free throw and TU's defense finally curtailed the bleeding with a stop. Coley's offensive rebound and layup put the Hurricane back up by five and TU staved off Charleston for a 62-53 victory. Duke had left before TU's poor second half performance. They had seen the Hurricane playing its best basketball and, according to Phillips, they were obviously prepared for a battle. "They came out against us and played like they were afraid we were going to beat them," he says. "They annihilated us. They gave us no mercy."

Tulsa trailed by 30 at halftime and that lead only increased in the second half. Six Blue Devils scored in double digits, including future NBA Lottery Picks Elton Brand and Shane Battier. They would advance to the championship game and lose to Connecticut. Up until that point, many college basketball experts believed Duke might be one of the greatest teams ever.

"I really thought that we could play with them," Self says. "I thought we were good enough defensively that we could guard them. I remember asking Coach (Norm) Roberts to tell me just one weakness and he said, 'Bill, I can't find one.'"

In hindsight, the 97-56 rout was a blessing in disguise. "I think the rest of the spring and summer our guys remembered that," Phillips says. "It really gave them a valuable lesson. They refocused on what it was going to take."

Tulsa finished the season at 23-10 and Ruffin and Kurtz were both named Second Team All-WAC. Junior college transfer Tony Heard made significant contributions and Harrington was named WAC Newcomer of the Year. Ruffin was the only senior on that squad and the returning core of players had the makings of greatness.

With the early departure of Zac Bennett and John Cornwell, Tulsa was able to pick up two more recruits. Junior college transfer David Shelton proved to be a valuable sixth-man off the bench and freshman Charlie Davis would later develop into one of TU's most prolific rebounders. The Hurricane jumped out to a seven-game winning streak including a road victory against St. Joseph's 79-73. Three years removed from his days at ORU, Self was no less stressed over the importance of the Mayor's Cup challenge.

"The pressure for Bill on that game was tremendous," Phillips says. "There was an issue with the referees. We were supposed to be able to assign the referees but here was a breakdown in communication and we ended up with [Mid-Continent Conference] referees. At the end of the game there were some very questionable calls. That always ate at Bill because he felt like ORU didn't treat us the way we should've been treated."

Nate Bynam's last second shot broke TU's winning streak and gave ORU a 60-59 victory. The loss also delayed Tulsa's entry into the Top 25. Self was the most disappointed Phillips had ever seen him. The former ORU coach never liked playing against his previous team and says those three games against the Golden Eagles were "absolutely no fun." But this particular loss turned out to be another turning point for Tulsa.

"I look back now and wonder if we would have been as good if that hadn't happened," Self says. "We needed to be humbled. You want your guys to be confident but were probably a little cocky at the time. That was obviously a humbling experience, not to lose to Oral Roberts, because ORU was good, but to lose to your in-state rival. After that, I was very tough on our guys."

Ten days later, Tulsa was in Bayamon, Puerto Rico for the Puerto Rico Holiday Classic. Phillips believes it was the best thing that happened for the team. TU opened with a Boston College team that featured a highly-touted freshman named Troy Bell. The Hurricane shut the newcomer down, allowing him to hit just 3 of 11 from the field for eight points. TU won 80-66 and advanced to play North Carolina-Charlotte. The 49ers were coming off an NCAA Tournament appearance and 23-win season, but Tulsa's defensive pressure was too much and the Hurricane won 76-60.

In the tournament final, Tulsa took on undefeated and #11-ranked Tennessee. The

Volunteers were led by junior point guard Tony Harris. TU's coaching staff felt confident going into the game that Tennessee was ripe for an upset.

"We knew by watching them that they were tremendously talented, but they were ready to get beat," Phillips says. "They were arguing with each other and they were a bunch of prima donnas. Everybody talked about how great Tony Harris was. On the first play of the game, [Harris] drove to the lane and went to the basket to shoot a layup. Marcus Hill and Eric Coley got to the ball and both of them blocked the shot. They called a foul and the kid landed on the floor on his back. None of his teammates came over to help pick him up and he just laid there. Our guys were sending them a message right there that this was going to be a war."

Tulsa destroyed Tennessee 88-68 in front of a modest crowd of 765 people in a tiny gymnasium. But the victory clearly caught the attention of the national basketball audience. TU received its first national ranking the next week and would be ranked for the rest of the season. As big as the win was for Tulsa's hoops program, Phillips contends that it had an even greater affect on the head coach.

"That tournament and that win probably made the biggest difference in Bill's career," Phillips says. "From that point on, we were on the national radar. We were one of the premier teams and the players gained so much confidence."

Throughout the rest of the season, Tulsa dominated most of its opponents and suffered just three more losses leading up to the NCAA Tournament. Ironically, all three games were against TU's arch-nemesis Fresno State. Those games were lost by a combined six points. Technically, Tulsa can now count them as wins due to Fresno State's use of ineligible players, but the University has chosen not to change the record books. Self says the reason TU struggled with the Bulldogs that season was clear.

"They could spread it and drive it," he says. "Fresno State was not better than us. Even Coach (Jerry) Tarkanian came into our locker room and apologized for winning the game. He said, 'You guys are better than us.' But they had the best personnel and they got up for us."

Despite Tulsa's phenomenal season and #18 national ranking, the Hurricane landed a disappointing #7 seeding for the NCAA tournament. Self asked a member of the selection committee how a team that was ranked in the Top 15 and had an RPI ranking the Top 15 could get such a low seed. He was told it boiled down to the three Fresno State losses. In hindsight, the snub turned out to be the catalyst for TU's Cinderella run. "We were hot," Self says. "We were mad."

Tulsa opened with former WAC opponent UNLV who had just left for the newly-formed Mountain West Conference. Although touted as a grudge match, Self contends that it's billing was merely used "for hype and for the press." The Hurricane landed early blows and ran away with an 89-62 victory. Shelton and Harrington paced TU with 21 and 16 points, respectively.

The win set up a second round meeting against #2 seed Cincinnati. The Bearcats lost the top seed after losing in the Conference USA final, not to mention star player Kenyon Martin, who had broken his leg. Even still, the #7-ranked team was a heavy favorite to defeat Tulsa. In pregame interviews, Cincinnati's starting forward Pete Mickeal was asked about matching up with senior Eric Coley. In replying, he referred to his counterpart as "Conley or whatever his name is." Journalist Ken MacLeod couldn't help but laugh at Mickeal's blatant disrespect.

"That was one of the all-time worst cases of sticking your foot in your mouth," MacLeod says. "When I heard him say that, I said to myself, 'That guy doesn't know who he's insulting.' He had just insulted one of the hardest-working, toughest characters that TU's ever had. [Coley] had gone through a lot. It was a total mistake on [Mickeal's] part."

Needless to say, Mickeal was quite familiar with Coley by the end of the day. Cooley had the game of his career with 16 points, 16 rebounds, four assists, four blocked shots and four steals. Tulsa was also boosted by Shelton's 14-point performance and a breakout game for freshman Dante Swanson, who scored 14 as well. It was a particularly sweet victory for Shelton, who hailed from Cincinnati. According to Self, Shelton was "so happy after the game he started crying."

"[Cincinnati] tried to intimidate our guys," he says. "They probably didn't know that we had

two guys on our team that were as tough as or tougher than anybody around. Tony Heard and Eric Coley thrived on that. It wasn't a wise move to try to intimidate our team."

"Eric Coley was the heart and soul of that team," Tramel adds. "Eric Coley, to me, will always be the epitome of the Tulsa basketball player. He was downgraded by schools from bigger conferences. He grew up as the small town guy who liked to ride horses and go to the rodeo. He had some adversity when his mother passed away but he gutted it out."

Tulsa's 69-61 upset of Cincinnati allowed the Hurricane to move on to a game against #23-ranked Miami (FL), led by Leonard Hamilton. Miami was the #6 seed and had upset #3 seed Ohio State to get there. A close game throughout, Tulsa pulled away towards the end for an 80-71 victory. All five starters scored in double figures.

TU had reached the Elite Eight for the first time and was one game away from the Final Four. The only thing standing in the way was a North Carolina team that had overachieved and by most accounts was one of the last teams to get into the NCAA Tournament. Howard recalls how surreal it was to hear that #18-ranked Tulsa was "the favorite to beat North Carolina and go to the Final Four."

The game turned into a trench war in which Coley fouled out with just six point and four rebounds. Tulsa was never able to neutralize North Carolina's inside game but still had a chance late in the game. Swanson stole the ball from Ed Cota and promptly dunked the ball on him in a spectacular display of athleticism. Tulsa was within three points, but Shelton's three-point attempt went array and the Tar Heels escaped with a 59-55 win.

"We were better than them," Self says. "But the stars never aligned that day. I remember having a weird feeling going into that game."

It took a couple of weeks for the 32-5 season to sink in with the coaches and players. It didn't take as long for the fans and media to ask the question, 'Was this TU squad the greatest team in TU history?'

"It has to be," Tramel argues. "There's no question. As good as the NIT championship team was under Nolan, you're really talking about apples and oranges when you talk about a team that makes it to the Elite Eight. They were a sniff away from the Final Four."

Coley was named First Team All-WAC and received Honorable Mention All-American accolades. Kurtz and Shelton were named Second Team All-WAC. Self was the WAC Coach of the Year and suddenly the prospect of losing him to another program became a distinct possibility. When he turned down an offer from Nebraska, most believed he would be back for another year. The NBA's summer jobs program put a kink in that plan. Lon Krueger took the head coaching job with the Atlanta Hawks and left a position open at Illinois. The Fighting Illini immediately came knocking on Self's door.

"If that had happened right after the season, I wouldn't have done it because I was too emotional with what was going on at Tulsa and how good everyone had been to me," Self says. "It was strange timing. I didn't want anything like that to occur because I was totally content where I was. Tulsa is not a mid-major job. Tulsa is a high-major job. It's a great job. There's unbelievable support and I always felt like the administration always gave you a chance to be successful. There's a commitment to winning."

Phillips recalls how the change affected the rest of the coaching staff. "Bill said we could go with him and initially that's what I wanted to do," he says. "Bill and I had a great relationship. A couple of days later, [assistant coach] Norm [Roberts] got involved with trying to get the head job. I talked to my wife and I'd just moved my mom here to a retirement home. All of my ties were here. I decided that if Norm got the job, I was going to stay for sure."

There were no guarantees for anyone at that point and the decision ultimately lay in the hands of Judy MacLeod and TU President Dr. Bob Lawless. After the biggest season in TU basketball history, the next head coach would have a large pair of shoes to fill and some lofty goals to reach.

Bill Self served as TU's head coach from 1997 to 2000. Self made the cross-town trek from Oral Roberts and before that had worked as an assistant at his alma mater Oklahoma State. Self led Tulsa to an overall 74-27 record and a pair of WAC titles. He was at the helm during TU's historic 1999–2000 season when the Golden Hurricane went 32-5 and reached the NCAA Tournament's Elite Eight. That season, Self was named WAC Coach of the Year, Sporting News National Coach of the Year and John and Nellie Wooden Coach of the Year. He was also a finalist for the Naismith Coach of the Year award. Following the 1999–2000 season, Self took the head coaching job at Illinois where he led the Fighting Illini to three consecutive NCAA Tournament appearances. In 2003, he replaced Roy Williams as the head coach at Kansas. (Courtesy of The University of Tulsa.)

Billy Gillispie worked as an assistant coach under Bill Self from 1997 to 2000. Gillispie followed Self to Illinois before taking his first head coaching job at UTEP where he spent two years before leaving to take the helm at Texas A&M. (Courtesy of The University of Tulsa.)

Norm Roberts served as an assistant coach under Bill Self from 1997 to 2000. He had previously worked with Self at ORU. The two continued to work together at Illinois and Kansas. After the 2003-04 season, Roberts was given his first opportunity to coach at the Division I level when he took the head job at St. John's. (Courtesy of The University of Tulsa.)

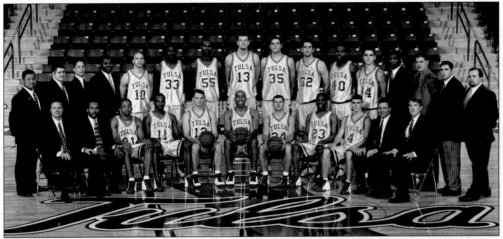

The 1998–99 team recorded a 23-10 mark and finished tied for first in the WAC. After losing in overtime to Utah at the WAC Championship, the Hurricane earned an at-large bid to the NCAA Tournament. Pictured, from left to right, are (sitting) Head Coach Bill Self, Assistant Coach Norm Roberts, Marcus Hill, Eric Coley, Jonnie Gendron, Michael Ruffin, Shawn Williams, Tony Heard, Jeff Platt, Assistant Coach Billy Gillispie and Assistant Coach John Phillips; (standing) Manager Abi Kartoatmodjo, Manager Peter McAdams, Manager Tony Bowles, Manager Seifullah Yero, Greg Harrington, Kevin Johnson, DeAngelo McDaniel, Brandon Kurtz, John Cornwell, Zac Bennett, Robert Bell, Clint Mills, Administrative Assistant Kwanza Johnson, Trainer Kevin Beets, Student Trainer Mike Salat and Equipment Manager Scott Lucas. (Courtesy of The University of Tulsa.)

TU's coaching staff poses for a picture on the Donald W. Reynolds Center construction site previous to its opening on December 29, 1998. Pictured from left to right are, Head Coach Bill Self, Assistant Coach Billy Gillispie, Assistant Coach John Phillips and Assistant Coach Norm Roberts. By the end of the 2003-04 season, all four men were Division I head coaches with Self at Kansas, Gillispie at Texas A&M, Phillips at Tulsa and Roberts at St. John's. (Courtesy of The University of Tulsa.)

Jonnie Gendron returned to the college basketball ranks after spending time in the Pittsburgh Pirates farm system. Gendron played for Tulsa from 1995 to 1999. As a sophomore, he led TU in three-point field goal percentage hitting 45 of 107 trey attempts (.421). He was twice named to the WAC All-Academic Team (1996–97 and 1997–98). A series of concussions kept Gendron off the court for his entire senior season except for one symbolic appearance against Rice. (Courtesy of The University of Tulsa.)

Shawn Williams played for Tulsa from 1997 to 1999. As a junior, he led TU in three-point field goal percentage hitting 39 of 96 treys (.406). In his final season, Williams received WAC All-Academic honors. (Courtesy of The University of Tulsa.)

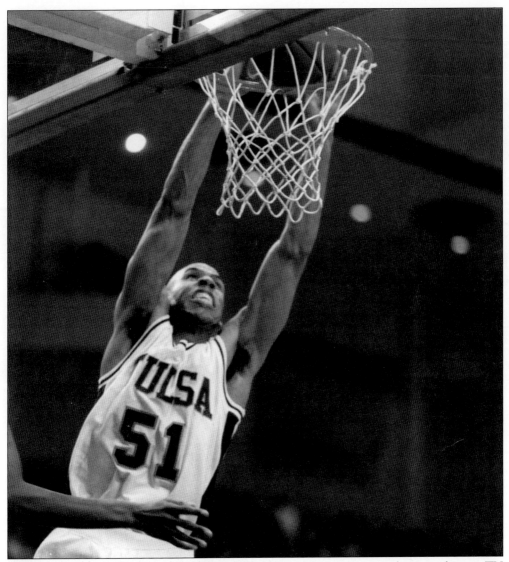

Michael Ruffin starred for TU from 1995 to 1999. He started in more games than any player in TU history (115) and emerged as one of the Golden Hurricane's most dominant defensive forces. Ruffin led Tulsa in rebounding and blocked shots in each of his four seasons. As a senior, he set the school's single-season mark for rebounds (342) and blocked shots (86). Ruffin also holds the single-game blocked shots mark with nine against Tulane during the 1998–99 season. He finished his career ranked first on TU's all-time rebounding chart with 1,211. His career 9.5 average is the highest of all four-year letterwinners. Ruffin is also ranked first on the all-time blocked shot list (266) and 17th on the all-time scoring chart (1,209 points). He was a three-time WAC All-Defensive Team selection and received both First Team All-WAC honors (1997–98) and Second Team All-WAC honors (1998–99). Ruffin was three times tabbed WAC All-Academic and as a senior he was named First Team Acadamic All-American. That same season, College Hoops Insider dubbed Ruffin the Student Athlete of the Year and he was named an NCAA Top VIII Award Recipient. Ruffin was selected by the Chicago Bulls in the second round of the 1999 NBA Draft and later played for Utah, where he spent the 2003–04 season. In 2004, he signed with the Washington Wizards. (Courtesy of The University of Tulsa.)

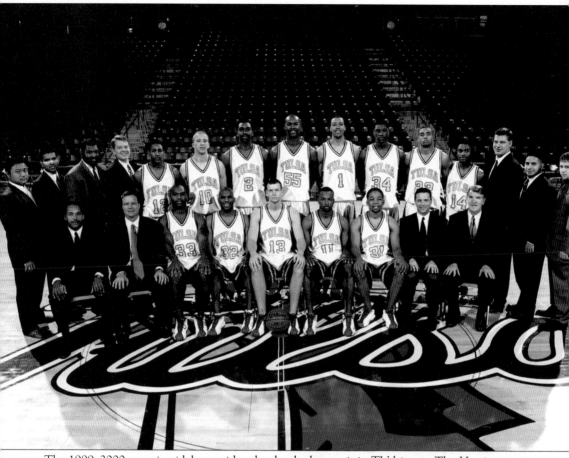

The 1999–2000 team is widely considered to be the best unit in TU history. The Hurricane went 32-5 and made a historic run to the NCAA Tournament's Elite Eight. Tulsa defeated UNLV, #7-ranked Cincinnati and #23-ranked Miami before losing to North Carolina in the South Regional Finals. Among all Division I teams, TU was ranked second in scoring margin (+17.5), 14th in scoring offense (80.4 points per game) and 27th in field goal percentage (.472). Tulsa recorded the nation's third highest won-lost percentage (.865) and set a school record for most wins in a season. The team's 433 steals is ranked 12th among the best NCAA single-season performances. Pictured, from left to right, are (front row) Assistant Coach Norm Roberts, Head Coach Bill Self, David Shelton, Tony Heard, Brandon Kurtz, Eric Coley, Marcus Hill, Assistant Coach Billy Gillispie and Assistant Coach John Phillips; (back row) Manager Abi Kartoatmodjo, Manager Mubashir Sharief, Manager Seifullah Yero, Academic Advisor Brad Autry, Dante Swanson, Greg Harrington, Charlie Davis, DeAngelo McDaniel, Marqus Ledoux, Kevin Johnson, Demario Hooper, Antonio Reed, Athletic Trainer Kevin Beets, Student Trainer Omar Zaldivar and Manager Kevin Renegar. (Courtesy of The University of Tulsa.)

Eric Coley pushes the ball downcourt in TU's 76-59 victory against Texas-San Antonio on December 1, 1999. Coley played for the Golden Hurricane from 1996 to 2000. Born in Rochester, NY, but raised in Eufaula, OK, he became one of the greatest defensive players to ever don the Tulsa jersey. As a senior, he matched the single-game steals record of eight against both UAB and Rice. Coley also set the single-season mark that year with 123 swipes. That mark ranks 11th among all NCAA Division I players. He led TU in assists as a junior (86) and senior (126). Coley was twice named to the WAC All-Defensive Team (1997–98 and 1999–2000). As a senior, he was named First Team All-WAC, honorable mention All-American (AP), South Region all-tournament, USBWA all-district and Basketball Times all-region. He finished his career ranked first in steals (299), third in blocked shots (136), fifth in assists (335), eighth in rebounding (697) and 18th in scoring (1,116 points). Coley also holds the school record for most

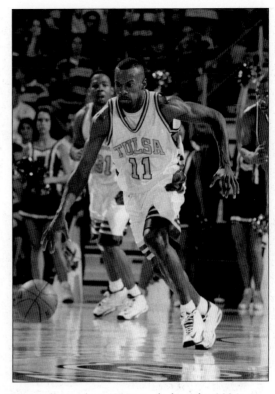

personal fouls (378). He went on to play professionally in the USBL, including the 2004 season at Oklahoma. (Courtesy of The University of Tulsa.)

TU mascot Captain Cane sports the popular "SELF DEFENSE" t-shirt from the 1999–2000 season. Under head coach Bill Self, Tulsa was known as one of the nation's stingiest defenses. In Self's final season, TU was ranked 19th nationally in field goal percentage defense (.393). (Courtesy of The University of Tulsa.)

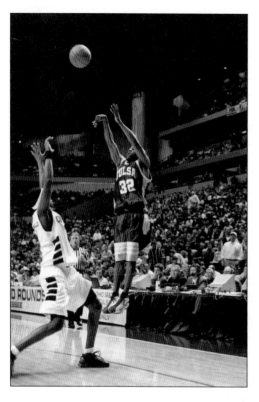

Tony Heard launches a baseline three-pointer in #18-ranked TU's 69-61 upset victory over #7-ranked Cincinnati in the second round of the NCAA Tournament on March 19, 2000. He played for the Golden Hurricane from 1998 to 2000. As a senior, Heard was TU's top three-point shooter hitting 78 treys. He was also named to the WAC All-Defensive Team. (Courtesy of The University of Tulsa.)

Brandon Kurtz jockeys for rebounding position in TU's 100-78 defeat of Hawaii on January 22, 2000. The Bakersfield, CA, native and junior college transfer led TU in scoring as a junior with 392 points (11.9) and paced the Hurricane in rebounding as a senior with 258 boards (7.0 average). Kurtz is ranked sixth on the school's all-time blocked shots chart with 80. He scored TU's first field goal in the Reynolds Center during the 79-51 victory against Cleveland State. Kurtz was twice named Second Team All-WAC (1998–99 and 1999–2000) and earned a spot on the WAC All-Newcomer Team in 1998-99. He went on to play professionally overseas in Spain, Turkey and Italy. Kurtz has also spent time in the USBL with St. Louis and Oklahoma and was a member of the 2004 NBDL Championship team in Asheville while earning Second Team league honors. (Courtesy of The University of Tulsa.)

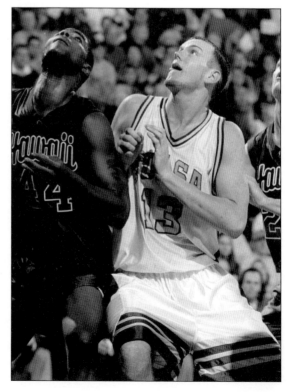

NINE
The Buzz Light Year
2000–2001

The head coaching job at The University of Tulsa was quickly becoming one of the most sought-after positions in the country. It had proven to be a breeding ground for future stars. By now, the school had played a part in the careers of championship coaches Nolan Richardson and Tubby Smith. Some of its assistants had moved on to take Division I jobs of their own. Ron Jirsa had been at Georgia and most recently at Marshall. Shawn Finney had followed Smith all the way to Kentucky before taking the top post at Tulane. Mike Anderson found a home at UAB, while former J.D. Barnett assistants Kevin O'Neill and Flip Saunders landed head positions in the NBA. And that's the short list.

In other words, landing the Tulsa job indicated that a coach was probably on the fast track to a major conference program. When Buzz Peterson won the sweepstakes, TU had found an ambitious young skipper fresh off an NCAA Tournament appearance with Appalachian State. In eight years as TU's play-by-play announcer, Bruce Howard was now working with his fourth head coach. It was obvious from the start that Peterson was cut from a different cloth.

"He had that down home, folksy style and accent," Howard says. "That was a little bit different than what we were used to. He was a nice guy and always very forthright."

Thanks to Judy MacLeod's recommendation, Peterson opted to keep Phillips on his staff as the associate head coach. His presence helped the players feel at ease with the change and the decision proved to be a wise one.

The 2000–01 season kicked off at the NABC Classic in Chapel Hill, N.C. It was familiar territory for Peterson who had played at North Carolina and was a member of the 1982 national championship team. He was Michael Jordan's college roommate and remained good friends with the NBA legend. Tulsa opened with a 69-67 victory against Arizona State. Dante Swanson stole a pass and hit the game-winning layup. Against #4-ranked North Carolina, the Hurricane lost 91-81 in a hard fought effort.

Tulsa's non-conference season was dotted with challenging opponents. The Hurricane defeated Rhode Island, Southwest Missouri State, Wichita State and Oral Roberts in overtime but lost a one-point game against Iowa and a blowout at the hands of #10-ranked Kansas. Early on, the team dealt with inconsistency thanks to a relatively inexperienced set of players.

"When you look at the makeup of that team, it was really pretty young," Phillips says. Marcus [Hill] and David [Shelton] were the only seniors. Dante, Antonio, Kevin and all of those guys

hadn't played very much. Everybody assumed they'd be good, but it was their junior and senior year when they became really good."

Had it not been for Fresno State, Tulsa would have likely captured the regular season WAC title. The Bulldogs again had TU's number, sweeping the two-game series. The Hurricane still managed a second place finish despite the 10-6 conference record. The WAC Tournament presented an exciting opportunity, with TU hosting the event at the Reynolds Center. It was the first in a three-year commitment.

The pressure of playing in front of the home crowd was evident in lackluster wins against San Jose State (64-53) and UTEP (59-56). But Hawaii had defeated Fresno State and TU felt confident it matched up well with the Islanders. At the time, Tulsa fans were unfamiliar with a freshman named Carl English. By his senior season, he would be known as a thorn in TU's side. But this year, English had averaged three points a game in a supporting role and was just starting to show signs of greatness with a breakout game against Fresno State.

The game went back and forth and with seconds to play, Shelton hit one of two free throws to give Tulsa a two-point lead. At the other end, English took the ball to the hoop and collided with Kevin Johnson. There was no foul called, but his tough 10-foot shot fell through and sent the game into overtime. Tulsa never recovered and lost 78-72. English finished the game with 25 points and six rebounds in just 25 minutes played.

TU's first round NIT game was against California-Irvine, a team that most fans knew little about. After falling behind by 20 points in the first half, the Hurricane was convinced that its opponent certainly deserved to be playing in the postseason. To its credit, Tulsa fought back and secured a 75-71 victory. It was the first time TU had won an NIT game since the title year in 1981.

The architect that designed the NIT brackets certainly didn't do Tulsa any favors. The Hurricane traveled to Minnesota for the second round where they were double-digit underdogs. Sophomore Kevin Johnson began to emerge as a force late in the season. Against the Golden Gophers, he shocked the home crowd by blocking a shot and grabbing the rebound all in one single-handed motion. Tulsa emerged victorious with a 76-73 overtime victory.

Somehow, Tulsa was then expected to get to Starkville, MS, two days later for a quarterfinal game against Mississippi State. With some impressive travel coordinating skill, Judy MacLeod managed to get the team home for a day of rest before a chartered flight on the day of the game. Another nip-and-tuck affair, junior Greg Harrington's heroics saved the day as Tulsa won 77-75.

"Greg hit a shot with about four seconds left to give us the lead," Howard remembers. "One of their kids raced down the court, actually stepped out of bounds and not called for it, then made a shot at the buzzer to win. But it was too late. The referee waved it off immediately then they went to the replay to make sure."

In New York, Tulsa was again given little chance to defeat John Calipari's Memphis club. TU came out on top 72-64 to earn a spot in the championship game against Alabama. Led by tournament MVP Marcus Hill, the Hurricane went out with a bang blowing out the Crimson Tide 79-60.

"I was really proud of that team," Phillips says. "When they got beat by Hawaii (in the WAC title game), they showed the mark of a great team by winning the NIT. In the history of our program, I don't know if there would've been any team that's done as well as they did in the postseason under such adverse conditions."

Amid the NIT whirlwind, rumors of Tennessee's interest in Peterson where already swirling. Phillips believes that may have played a part in TU's amazing championship run. "I think that the players had gotten wind that Buzz was leaving," Phillips says. "They weren't mad at him, but I think they just decided they didn't want the season to be over."

"Even during the NIT, we heard that Tennessee had a job opening and Buzz Peterson was on their list," Howard adds. "I wasn't surprised about it as much because I'd been hearing about it. In retrospect, nine months isn't a very long period of time, but sometimes those dream jobs come along and I believe him when he said it was one of the jobs he'd always wanted."

When Peterson took the Tennessee job, it allowed him to go back to his roots. He was raised

near Knoxville and the allure of the SEC was too good an offer to refuse. But from the players' and the fans' perspectives, TU's coaching carrousel was spinning out of control. The program had gone through three coaches in six years and everyone knew it was time to calm the waters. The University of Tulsa needed someone that would be loyal to the city and the school. The big question was, would that individual come from the outside or was he sitting right under the school's nose?

Buzz Peterson was TU's head coach during the 2000–01 campaign. Peterson came to Tulsa from Appalachian State and led the Golden Hurricane to a 26-11 season and the school's second NIT Championship. His 26 wins matched Nolan Richardson's mark in 1980–81 for the most by a first-year head coach (a record that would be bested by John Phillips a year later). After less than a year on the job, Peterson took a head coaching position with Tennessee. (Courtesy of The University of Tulsa.)

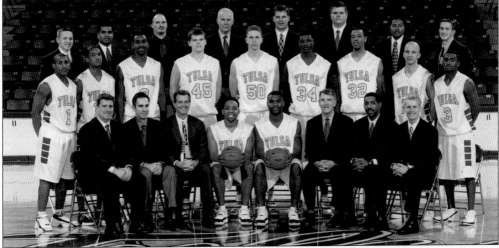

The 2000–01 team posted a 26-11 record en route to the school's second NIT championship. The Golden Hurricane finished second in the WAC with a 10-6 mark and narrowly missed out on the NCAA tournament by losing to Hawaii in the WAC Tournament. Pictured, from left to right, are (front row) Director of Basketball Operations Ed Conroy, Assistant Coach Kerry Keating, Head Coach Buzz Peterson, Marcus Hill, David Shelton, Associate Head Coach John Phillips, Assistant Coach Al Daniel and Student Assistant Eric Konkol; (middle row) Dante Swanson, Jason Parker, Charlie Davis, J.T. Ivie, Jack Ingram, Kevin Johnson, Marqus Ledoux, Greg Harrington and Antonio Reed; (back row) Manager Matt Quade, Manager Mubashir Sharief, Strength Coach Sean Hayes, Team Physician George Mauerman, Trainer Kevin Beets, Student Trainer T.J. Horton, Manager Nick Agimudie and Manager David McCarthy. (Courtesy of The University of Tulsa.)

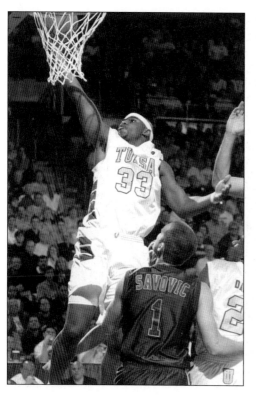

David Shelton shoots a layup as Predrag Savovic of Hawaii and Golden Hurricane teammate Charlie Davis look on. Despite Shelton's efforts, TU came up short in the WAC Championship game against Hawaii, losing 78-72 in overtime. Shelton played for Tulsa from 1999 to 2001 after transferring from Independence Community College. Coming off the bench, the Cincinnati, OH, native led TU in scoring as a junior with 498 points (13.5 average). That year, he was named to the WAC All-Newcomer Team and received Second Team All-WAC honors. Shelton was the team's best free throw shooter the following season with a .830 average. He went on to play professionally, including time in Mexico during the 2004 season. (Courtesy of The University of Tulsa.)

Marcus Hill played for TU from 1997 to 2001. The Tulsa, OK, native from Booker T. Washington High School led the Hurricane in three-pointers as a senior with 78 treys. That same season he was named MVP of the NIT following TU's championship run. He ended his career as the 12th best scorer in school history with 1,389 points (10.4 average). Hill also finished ranked ninth on the all-time assists chart with 302, 10th on the all-time steals list with 136 and third on the all-time games played chart with 134. He went on to play professionally both in Europe and in the U.S.-based ABA and USBL. (Courtesy of The University of Tulsa.)

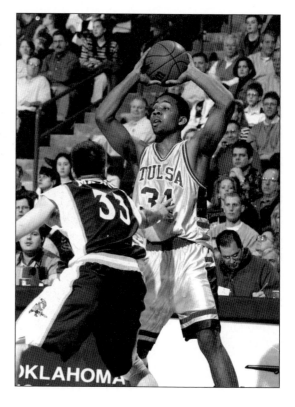

Greg Harrington played for the Golden Hurricane from 1998 to 2002. He was named WAC Freshman of the Year and earned a spot on the WAC Mountain Division's All-Newcomer Team. As a junior, Harrington led TU in three-point field goal percentage hitting 52 of 111 attempts (.468). He also set Tulsa's single season assist record with 201. As a senior, Harrington was named First-Team All-WAC. He owns the school's career assist mark (551) and games played record (141). Harrington also ranks sixth on TU's all-time scoring chart with 1,520 for a 10.8 average. He went on to play professionally in Europe, including the 2004 season in Poland. (Courtesy of The University of Tulsa.)

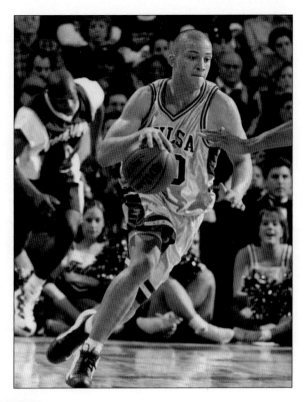

Kevin Johnson (foreground) and Jason Parker (background) join the rest of the 2000-01 team as hundreds of TU fans line up for autographs from the 2001 NIT Champions. After a close call against UC-Irvine at the Reynolds Center (75-71), TU scrapped out challenging road victories against Minnesota (76-73 in OT) and Mississippi State (77-75) before advancing to New York where the team defeated Memphis (72-64) and Alabama (79-60). (Courtesy of The University of Tulsa.)

Charlie Davis played for Tulsa from 1999 to 2003. Although not a highly touted recruit, Davis developed into one of TU's steadiest forces on the boards. He paced the Hurricane in rebounding as a junior with 229 (6.7 average) and as a senior with 230 (7.0 average). Davis also led Tulsa in field goal percentage in both of his final two seasons with averages of .629 and .559 respectively. His performance as a junior ranks second among the best averages in school history and was the best since Julian Hammond's school record .659 percentage 36 years earlier. Davis finished his career ranked 11th on TU's all-time rebounding chart with 662 (5.0 average) and 15th on the all-time blocked shots list with 44. (Courtesy of The University of Tulsa.)

After transferring from LSU, Marqus Ledoux played for TU from 2000 to 2003. Ledoux saw action in 96 career games and averaged 4.2 points and 2.0 rebounds. While his numbers were below the expectations of some fans, he often came off the bench to provide a spark of offensive intensity. Ledoux went on to play professionally in Europe, including the 2004 season in Austria. (Courtesy of The University of Tulsa.)

TEN
The Phillips Factor
2001–2004

For six of Tulsa's returning players, the next head coach would be their third in three years. The University was facing one of the most pivotal moments in its storied basketball tradition. TU desperately needed a steadying force. It needed someone that could not only win ballgames, but someone that would commit to the program's long-term goals. With all of the criteria laid out, it became increasingly clear that John Phillips was the perfect man for the job.

"It was the right situation for me," Phillips says. "The way that group had finished the year solidified their hold on the program. If they could do that with two different coaches, then their input was going to be very important. I think Judy [MacLeod] was very concerned that if she brought in a third guy that wasn't necessarily loyal to Tulsa and he leaves after two years, what was that going to do? I think it was very good timing for me."

Not only was Phillips a Tulsa native, he had also earned his Master's Degree from TU in 1978 and was a graduate assistant under Jim King. He had a great appreciation for the basketball team's history and understood the obstacles it had faced and overcome. Phillips had followed TU hoops from the Clarence Iba years and beyond. With his hiring, Phillips likened the team to "a family that had stuck together."

"I think it was medicine for that team," Jimmie Tramel observes. "The players almost felt orphaned. When you go through changes like that, there are trust issues. By hiring Phillips, it allowed players to have some trust in the next head coach. I think it was evident by the smile on Greg Harrington's face because he knew he wouldn't have to go through anymore turbulence. Phillips offered stability."

Upon getting the job, the first thing Phillips did was travel to Georgia and visit a young recruit named Jarius Glenn. He had verbally committed to Tulsa when Peterson was still the coach. Even though the recruiting process didn't start on his watch, he claims Glenn as his own due to the sales pitch he had to give in order to keep him from changing his mind. It wasn't long before TU fans began to appreciate the warrior mentality that Glenn brought to the table.

"He's a tough kid," Phillips says. "He's had a really difficult upbringing. He really raised himself. But when you get to know him, underneath that toughness that he has, he's like a teddy bear. Everybody loves him. He's got this tough veneer, but he is a sweetheart. He treats people with respect. I don't know if I could come out of the environment that he did and have the outlook that he does."

Phillips doesn't remember much about his first season in 2001–02. It was all a blur. TU opened up with a 9-1 tear that included an overtime victory at Oral Roberts (73-66) and wins over Buffalo, Montana and BYU-Hawaii in Laie, Hawaii where the Hurricane claimed the Yahoo Sports Invitational. Tulsa's only loss during that stretch was a 79-75 home loss against Arkansas. The great start only intensified the team's blissful attitude.

"The whole season was like we'd gotten a reprieve," Phillips says. "The players enjoyed not having to prove themselves to somebody new and I enjoyed the fact that I didn't have to prove myself to them. It was like we were on a honeymoon together. We were winning games and playing well. Greg and I were really close. Everybody wanted him to have a successful year. All of the players respected Greg. It gave me and him an opportunity to lead the team."

After a closely-contested loss at Kansas (93-85), the Hurricane entered the WAC season as one of the favorites to contend for its title. In the second conference game at Fresno State, TU lost its sixth straight game against the Bulldogs (86-85) but rebounded for five straight victories. On January 31, 2002, TU got the proverbial monkey off its back with a resounding 78-63 triumph against FSU. By now, Hawaii had replaced them as TU's new nemesis having defeated the Hurricane in three straight games dating back to the previous year. Otherwise, the Hurricane was perfect in conference and posted a 15-3 record that landed the team in a tie for first place.

The WAC Tournament was held at the Reynolds Center in Tulsa for a second straight year. After losing the title game 12 months earlier, the pressure was on Harrington and the team's five juniors to keep the trophy from leaving town again. After two games, the prospects of a championship and automatic NCAA bid looked favorable. TU breezed past Boise State (72-52) and Fresno State (81-65) for another shot at Hawaii. Tulsa buckled under the intense pressure and never seemed to get unhitched. Hawaii's trio of Carl English, Phil Martin and Predrag Savovic played a key role in the 73-59 defeat of the host Hurricane.

The loss forced TU to play that all too familiar waiting game. No one was terribly surprised to see the Hurricane as the #12 seed one more time. Tulsa was matched up against #12-ranked Marquette. The Warriors were one year away from reaching the Final Four and presented a formidable challenge. Most pundits predicted an early exit for Tulsa. ESPN announcer Dick Vitale was one of many that had already slated Marquette to face Kentucky in the second round.

Tulsa jumped out to a 14-point lead early in the second half, but Marquette made a late comeback and overtook the Hurricane with less than a minute remaining. Harrington hit one of his trademark floater jump shots in the lane with 14 seconds left to win the game 71-69. Phillips calls the Marquette victory his "highlight of the year" because it put Tulsa "back on the national scene."

In the second round, TU faced Tubby Smith's #16-ranked Kentucky Wildcats. The game turned into a shootout between Tulsa and Tayshaun Prince. The future Detroit Pistons star fueled Kentucky's efforts with a monstrous 41-point performance. Prince was responsible for nearly half of his teams scoring in the 87-82 final. Phillips was ecstatic to see the young man have such a great series in the 2004 NBA Finals against Los Angeles. "I'd hate to think that his whole career was our game," he says.

"We just didn't have an answer for him," Howard adds. "He could do so much. If you put a little guy on him, he'd post him up and if you put a big guy on him, he would use some of his perimeter skills to score."

Phillips made history in his first season at TU. The team's 27-7 record ranked as the third best in school history. His 27 win total was the most by a rookie coach (surpassing Nolan Richardson and Buzz Peterson who each had 26). Phillips also became the first TU coach to win an NCAA tournament game in his first year. Harrington ended his career as the all-time assists leader with 551 and was named First Team All-WAC. Johnson had a breakthrough year as the team's leading scorer (14.5 points per game) and was named Second Team All-WAC. Swanson led the nation in three-point field goal percentage (.490) and was named both Second Team All-WAC and WAC All-Defensive Team.

Tulsa's near miss opportunity to reach another Sweet 16 caused fans to chomp at the bit for the

2002-03 season. TU's senior class was like no other since Nolan's group from the 1981–82 campaign.

"The expectations were unbelievable," Phillips recalls. "Everybody was predicting that everything was going to be hunky dory. Every team handles pressure differently and that team I thought would eventually handle it well. But I think it affected the way we played early in the season. Early on, I don't think they really relaxed. There were a lot of games that year where I felt like we were going through the motions."

The talent level alone allowed TU to sleepwalk through the early part of its schedule. Tulsa won seven of its first eight games including a 61-60 nailbiter at Arkansas. But it was the two losses that had some onlookers concerned. The first was to #20-ranked Kansas at the Reynolds Center. While the defense gave special attention to Kirk Hinrich and Wayne Simien, it was big man Nick Collison that made the difference. He scored 26 points and corralled 12 rebounds to lead the Jayhawks to an 89-80 "upset" of the #17-ranked Hurricane.

Another heartbreaking loss came when Iowa visited town to face TU's #20-ranked squad minus an injured Dante Swanson. It was another chance for Tulsa to play a big conference school on its home court. Chauncey Leslie and Jeff Horner combined for 36 of the Hawkeyes' points in Iowa's come-from-behind 67-63 win. Tulsa stumbled through the WAC season but managed to stay afloat and near the top of the standings. An overtime home loss to SMU (86-84) coupled with road losses against San Jose State (58-57) and Hawaii (73-67 in overtime) made it difficult for TU to keep pace with frontrunner Fresno State.

Following the Hawaii loss, the first of two major turning points took place. Fans were shocked to learn that senior guard Antonio Reed had been dismissed from the team for violating team policies. While speculation ran rampant over the cause of Reed's departure, Phillips was visibly shaken by a decision that he had no choice but to make. In hindsight, he was able to see how his team turned such a negative situation into a positive reinforcement of what they were supposed to do.

"Losing Antonio at the end of that year with 10 games to go really woke up that team," Phillips says. "They were underachieving and [the seniors] realized they needed to take advantage of their last year. Kevin Johnson and Dante Swanson played tremendously the rest of the way. They were our go to guys."

Tulsa got hot late in that season and won eight of its last nine conference games. The Hurricane dropped a non-conference game at Gonzaga as part of ESPN's Bracket Buster Saturday series (69-60) before taking four straight WAC games leading up to the conference tournament. Late in the season, a second major event took place when Fresno State announced it was self-imposing postseason sanctions while undergoing an NCAA investigation. With the WAC favorites out of the tournament, there was a scramble for second place, which was now the #1 seed. Tulsa took the challenge and secured the top spot with a season-ending victory at Nevada (79-73).

TU was on a mission. The WAC Tournament was in its third and last year at the Reynolds Center and the four seniors were determined to not let this chance pass them by. The Hurricane destroyed UTEP 81-47 and took care of 2002 tournament champion Hawaii in the semifinals 66-56. Carl English single-handedly kept the Warriors in the game with his 33-point performance, but Tulsa's balanced offensive attack and sound first-shot defense was too good.

In the championship game, Tulsa faced a new challenger in the Nevada Wolf Pack led by future NBA first-round draft pick Kirk Snyder. But on TU's home stage, Swanson stole the show with a 23-point performance followed by four other Hurricane players in double figures. Tulsa had finally won that elusive tournament title and earned its first automatic NCAA bid since 1996 when the team was still in the Missouri Valley Conference. Kevin Johnson was named MVP with 14.6 points, 5.0 rebounds and 3.6 blocked shots.

Five days later, Tulsa was in Spokane, Washington, for its first round NCAA game against #22-ranked Dayton. The Hurricane was the #13 seed taking on a #4 seed, but experts knew better than to write the underdogs off this time. TU methodically climbed out to a big lead thanks to big plays from Swanson and Jason Parker. The two mirrored each other with 24 points and six assists in an

84-71 dismantling of the Flyers. Howard recalls talking to a journalist that commented on how it was "the least emotional upset of a #4 seed." The writer was amazed at how calm and unaffected TU was by its accomplishment.

"That's what they expected to do," Howard says. "There was a lot of senior leadership on that team and they'd been to this level before. They understood and I think they thought they were better than a #13 seed. For them to beat the #4 seed wasn't a big deal and you saw that in the lack of celebration."

Much like the first round game, Tulsa started off its second round meeting with Wisconsin by employing an aggressive game plan. The Hurricane dominated throughout most of the contest and enjoyed a 58-45 lead with 3:45 to play. After the media timeout, chaos broke loose and before Tulsa knew what had happened, they were clinging to a one-point advantage.

"I don't even want to talk about the last four minutes of that game," Phillips says. "Everything that could go wrong went wrong. Everything that could go right for Wisconsin went right. It was so frustrating as a coach."

With Tulsa leading 60-58 and seconds ticking away, Wisconsin collected a rebound and raced down the court. Swanson was the only player that got back and was forced to defend one of two Badgers. He picked the player that was wide open underneath the basket and left Freddie Owens open on the left wing. Owens had sprained his ankle in the first round and was a 20 percent three-point shooter. As he launched the shot, Swanson desperately lunged back towards Owens hoping to get a piece of the ball. With one second remaining, the bomb dropped through and TU was left shell shocked by the nightmarish ending.

"In my 30 years of coaching, I have never not known what to say to a team," Phillips admits. "I had no idea what to tell these guys."

Tulsa's senior class was devastated. After the sting of defeat had worn off, it was perhaps easier to reflect on their accomplishments. Johnson, Swanson and Davis had played on three NCAA tournament teams including the Elite Eight team of 2000. They had also won an NIT championship and were part of the most successful four-year period in TU basketball history. They were part of the nation's 10th best program during that time with a 108-33 record.

The bitter ending to the season was also tempered by some individual honors. Johnson was named First Team All-WAC and WAC All-Defensive Team. Swanson and Parker were both selected as Second Team All-WAC recipients. Phillips proved he wasn't a one-hit wonder and in fact became just the second TU coach to reach 50 wins in two seasons matching Nolan's two year total.

The first two years of Phillips career were going to be difficult to repeat. TU was losing five seniors (including Reed) and only had one upperclassmen returning in Parker. Junior Jarius Glenn was the only other player with significant experience coming back for Tulsa. Still, hopes remained high for yet another winning season. The 2003-04 year got off to a predictable start as the Hurricane handily defeated Northwestern State 78-49. The next game presented a much more formidable challenge.

In Norman, Tulsa faced an improving Oklahoma team that was sure to be dangerous on its home floor. The Hurricane hung tough and was down by four points with 1:46 to play before the Sooners pulled away for the 81-73 win. By the end of non-conference play, TU was holding a disappointing 4-5 record. It was the school's worst start since the 4-7 mark that kicked off the 1987-88 season. Tulsa showed signs of potential with wins against TCU and New Mexico State, but lost close games against Georgia State, ORU, Wichita State and Arkansas.

"They lost some close games early that they could have won," Howard says. "I still thought they had a reasonable chance to be a good team at the end of the year. On the air, we kept preaching patience because this was a young team coming together. My expectation was not to expect too much."

Early in the WAC schedule, Tulsa fought through chemistry issues. It was becoming obvious that the team's lack of a true point guard was a point of contention. To make things worse, TU was routinely getting killed on the boards. In particular, teams were having a field day with offensive

rebounds and taking advantage of the second and third chances. Tulsa had a solid first-shot defense, but it was doing them little good.

With a 3-5 conference record, Tulsa lost a confidence-breaking double-overtime loss against Hawaii (73-71). Another double-overtime defeat at the hands of Rice (113-103) nearly broke the team's spirit. TU finished the regular season winning two of its last three, but took an early exit at the WAC Tournament in Fresno with a 79-60 loss to SMU.

"You never go into a season thinking you're not going to be successful," Phillips says. "Going into the season, I knew that we could be competitive. There's no excuse. It was a bad year. There is no excuse that I can give to justify the kind of year we had. I'm not the kind of guy who's going to point fingers and blame somebody else. I know it's my responsibility to make sure it doesn't happen again."

The 9-20 season was Tulsa's worst record since J.D. Barnett's 1987–88 team recorded an 8-20 mark. Some pundits felt like it was TU's point guard dilemma that ultimately played the biggest factor. Senior Jason Parker was the team's leading scorer with 16.9 points per game but also paced the squad with 83 assists. Howard feels like Parker was dealt an unfair portion of the blame.

"It's so hard to come up with a true point guard anymore, a guy that's a really good distributor," Howard says. "Jason had to take over some of those duties. He had a great career and was a wonderful ambassador for TU because of his academics. I thought he did a great job getting through a difficult situation without losing his cool."

Parker finished his career ranked among the school's best in scoring (10th), assists (sixth), steals (seventh) and three-point field goals (sixth). He was a two-time Academic All-American and four-time WAC All-Academic honoree.

At the onset of the 2004-05 season, TU's basketball team faces challenges just like the ones many of its hoops brethren had faced before them. Based on past experiences, one can only believe that the Golden Hurricane will rise above adversity and continue to reach for that ultimate prize. Otherwise, there would be no reason to play the game.

John Phillips became the 28th head coach at The University of Tulsa prior to the 2001-02 season. Previously, he had served as an assistant coach under Bill Self from 1997 to 2000 and as the Associate Head Coach under Buzz Peterson for the 2000-01 campaign. He was also a graduate assistant under Jim King in 1977–78 while earning his master's degree at TU. In his first three seasons, Phillips compiled a 59-37 record and became only the second coach in school history to win 50 games in his first two seasons. He was the first coach in TU history to win an NCAA tournament game in his first season and his 27 victories is the most by any first-year Tulsa coach. He led the Golden Hurricane to a regular season WAC title in 2001–02 and a WAC tournament title in 2002-03. (Courtesy of The University of Tulsa.)

Former TU player Alvin "Pooh" Williamson returned to his alma mater in 2001 to serve as an assistant coach under John Phillips. Previously, he spent two years as an assistant at both Washington State and Illinois State and most recently a year at Tulane. The 2003–04 season marked Williamson's eighth year of NCAA Division I coaching experience. (Courtesy of The University of Tulsa.)

Former TU player Kwanza Johnson assumed an assistant coaching position in 2001 under John Phillips. Johnson previously served as an administrative assistant under Bill Self from 1997–99. He followed that with consecutive seasons as an assistant coach at Cal Poly-San Luis Obispo and Arkansas-Little Rock. The 2003-04 season was Johnson's seventh year of NCAA Division I coaching experience. (Courtesy of The University of Tulsa.)

The 2001–02 team went 27-7 in John Phillips' first season and earned an at-large NCAA Tournament bid. Tulsa finished tied for first in the WAC and won its first-round NCAA Tournament game against #12-ranked Marquette before losing to #16-ranked Kentucky in the Round of 32. Pictured, from left to right, are (front row) Director of Basketball Operations Ja Havens, Assistant Coach Alvin "Pooh" Williamson, Head Coach John Phillips, Greg Harrington, Assistant Coach Steve Cooper and Assistant Coach Kwanza Johnson; (middle row) Gianni Martins, Dante Swanson, Trevor Meier, Jarius Glenn, Marqus Ledoux, Jack Ingram, J.T. Ivie, Kevin Johnson, Charlie Davis, Jason Parker, Kyle Blankenship and Antonio Reed; (back row) Manager Ryan Burcham, Student Trainer Jacob Newburn, Strength Coach Sean Hayes, Athletic Trainer Kevin Beets, Team Physician George Mauerman, Manager Nick Agimudie, Manager Mubashir Sharief and Manager Matt Quade. (Courtesy of The University of Tulsa.)

Kevin Johnson takes it strong to the hoop in TU's 71-69 upset of #12-ranked Marquette at the first round of the 2002 NCAA Tournament. Johnson played for Tulsa from 1999 to 2003. A home school product from Texas, he finished his career as TU's fifth-leading scorer with 1,577 points for an 11.9 average. Johnson also ranks seventh on the all-time rebounding chart with 719 rebounds for a 5.4 average. He is second in blocked shots with 251 and shares the school's single season mark with 86. Johnson was named Second Team All-WAC as a sophomore and junior and earned First Team honors as a senior. That same season, he was named to the WAC's All-Defensive Team and was the WAC Championship MVP. He spent his first season away from Tulsa playing professionally in Turkey, where he was the league MVP and later signed to play in France. (Courtesy of The University of Tulsa.)

Dante Swanson gets eye level with the backboard in TU's 104-61 defeat of Grambling on November 19, 2001. Swanson played for Tulsa from 1999 to 2003. The Wagoner, OK, native led Tulsa in three-point shooting as a junior with 73 treys and the nation's best percentage at .490. He paced TU as a senior with 89 three-pointers and a .430 average. Swanson finished his career ranked ninth in scoring (1,433 points for a 10.3 average), second in three-pointers (250), 11th in assists (297), fifth in steals (179), 11th in blocked shots (59) and second in games played (139). He was twice named WAC All-Defensive Team and twice named Second Team All-WAC. He went on to play professionally in Europe, including the 2004 season in Poland. (Courtesy of The University of Tulsa.)

The 2002–03 team finished 23-10 and earned an automatic NCAA bid by winning the WAC Tournament. Tulsa upset #22-ranked Dayton in the first round of the NCAA Tournament before losing a heartbreaking last second game against Wisconsin. Pictured, from left to right, are (front row) Assistant Coach Alvin "Pooh" Williamson, Head Coach John Phillips, Marqus Ledoux, Dante Swanson, Charlie Davis, Kevin Johnson, Assistant Coach Steve Cooper and Assistant Coach Kwanza Johnson; (middle row) Director of Basketball Operations Ja Havens, Chris Wallace, Trevor Meier, Jarius Glenn, Aliou Keita, Anthony Price, Seneca Collins, Jason Parker, Kyle Blankenship and Athletic Trainer Kevin Beets; (back row) Manager Ryan Burcham, Manager Nick Agimudie, Manager Corey Litton, Team Physician Dr. George Mauerman, Strength Coach Rusty Burney, Manager Matt Quade, and Student Trainer Bernard Aguillard.

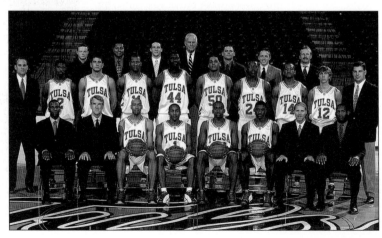

Pictured, from left to right, are Marqus Ledoux, Charlie Davis and Kevin Johnson posing in their cap and gown attire at The University of Tulsa's 2003 graduation ceremony. Despite having some of the most stringent academic requirements among NCAA Division I schools, TU has consistently produced some of the most successful student-athletes. Tulsa boasts 24 Academic All-Americans and countless conference All-Academic honorees. In 2002, TU finished in the top 10 of all three categories used to measure the success of student-athletes. In 1995, Tulsa ranked 10th in overall freshmen student-athlete graduation rate (80 percent), ninth in percentage-point difference between grad rate of athletes and student body (+19) and second in percentage-point improvement from freshmen entering in 1994 (+23). In 2003, TU finished second in overall 1996 freshmen athlete graduation rate (89%) just three percentage points behind Notre Dame. (Courtesy of The University of Tulsa.)

Jason Parker played for the Golden Hurricane from 2000 to 2004. Parker led TU in scoring as a senior with 490 points for a 16.9 average and as a junior with 509 points for a 15.4 average. He also led Tulsa in steals as both a senior and junior with 47 and 62 respectively. Despite pacing TU in scoring, he also led the way in his last season with 83 assists matching his previous year's feat with 134 assists. Parker set the school's single-game record with eight three-pointers against Wichita State during the 2002-03 season. For his career, Parker finished ranked among TU's top all-time performers with 1,401 points (10th), 322 assists (sixth), 166 steals (seventh) and 163 three-pointers (sixth). He also excelled in the classroom and was named Second Team Academic All-American as a senior and Third Team Academic All-American as a junior. Parker became the first TU basketball player to earn WAC All-Academic honors in each of his four seasons. He topped off his career by being named one of three finalists for the Creamland Dairies College Basketball Award of Excellence. (Courtesy of The University of Tulsa.)

Jarius Glenn entered TU's basketball program in 2001. He made an immediate impact as a freshman playing in all 34 games. As a junior, Glenn led Tulsa with 178 rebounds for a 6.1 average and was named to the WAC's All-Defensive Team. He was also TU's second-leading scorer with 365 points and a 12.6 average. Prior to his senior season, Glenn had tallied 834 points, 422 rebounds, 145 assists and 91 steals with the likely chance of entering the school's top 25 in three or more categories. (Courtesy of The University of Tulsa.)

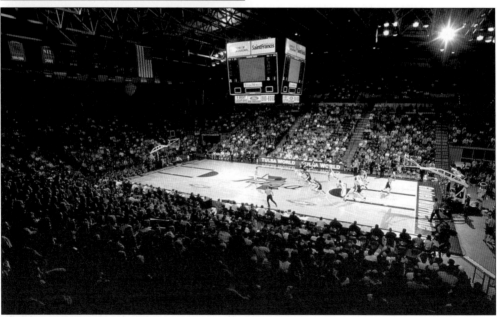

Pictured is game action at the Donald W. Reynolds Center. The Reynolds Center hosted its first basketball game on December 29, 1998 when TU defeated Cleveland State, 79-51. The facility seats 8,355 fans and came with a $32 million price tag. Through the 2003–04 season, the Golden Hurricane had posted a combined 71-18 record on its home court. The Reynolds Center hosted three consecutive WAC Championships from 2000-2003. (Courtesy of The University of Tulsa.)